PARIS OF THE PLAINS

KANSAS CITY
from Doughboys to Expressways

JOHN SIMONSON

Charleston · London

THE
History
PRESS

Published by The History Press
Charleston, SC 29403
www.historypress.net

Copyright © 2010 by John Simonson
All rights reserved

*Cover photos courtesy of Missouri Valley Special Collections, Kansas City Public Library, Kansas City,
Missouri. Map courtesy of author.*

First published 2010

Manufactured in the United States

ISBN 978.1.60949.062.1

Library of Congress Cataloging-in-Publication Data

Simonson, John.
Paris of the Plains : Kansas City from doughboys to expressways / John Simonson.
p. cm.
Many of these stories were first published at parisoftheplains.com or at kcfreepress.com"--
Preface.
ISBN 978-1-60949-062-1
1. Kansas City (Mo.)--History--20th century. 2. Kansas City (Mo.)--Biography--Anecdotes.
3. Kansas City (Mo.)--Description and travel. I. Title.
F474.K257S56 2010
977.8'411--dc22
2010035935

For Kansas Citians: past, present and future.

CONTENTS

CONTENTS

PREFACE

It's been said that journalism is the rough draft of history. Of course, some drafts are rougher than others. Journalists are professional truth tellers, but truth can be subject to differing points of view.

That said, the stories in this book are based on stories first told by journalists of their time, primarily by those working for the daily *Kansas City Journal* and *Post*, the daily *Kansas City Star* and *Times* and the weekly *Kansas City Call*, but also by those at national wire services, magazines and newspapers in cities and towns all over America. In most cases, I've had the benefit of using additional archival sources to further inform the stories.

Except where I clearly signal my own imaginings, all dialogue comes from the news stories, either witnessed by reporters or confirmed for them by people present when it was spoken, and any thoughts attributed to people come from the reporters' accounts. In all cases, accuracy has been my primary goal.

Many of these stories were first published at http://parisoftheplains.com or at http://kcfreepress.com.

ACKNOWLEDGEMENTS

Many thanks go to the Kansas City, Missouri, Public Library, where the staffs of the Missouri Valley Special Collections and the Reference Desk have been enormously helpful.

I am grateful to Rebecca McClanahan for her mentoring and encouragement.

And special thanks go to my family, particularly to Susan, Eliza and Blossom.

INTRODUCTION

Keep your places, objects than which none else is more lasting!
—Walt Whitman, "Sun-Down Poem," 1856

A time traveler from the twenty-first century, I'm standing on the observation deck of the Liberty Memorial, looking north across the monument's newly mown lawn toward the skyline of Kansas City, Missouri, circa 1950. It is summertime and, according to the clock on the Kansas City Southern Lines billboard, 10:49 in the morning.

I see some familiar landmarks: Union Station, for instance, and the Power and Light Building, city hall, Municipal Auditorium and the dome of the Cathedral of the Immaculate Conception. And I see things that are missing from the twenty-first century: train sheds behind the station, the Jones Department Store, the hotels Continental and Kansas Citian, whole blocks of buildings and sidewalks and trees not yet obliterated by freeways.

Here, the H.D. Lee Company still has its headquarters in the nine-story brick building behind Union Station, and members of my mother's family still work there. From the Lee building, it's a short walk in either direction to the former T.J. Pendergast Wholesale Liquor Company or to the second-floor office that belonged to Pendergast.

In 1950, Boss Tom has been dead five years.

Paris of the Plains—some could say that's pretty highfalutin for a rough-cut cattle town. Or they could point out a fudge on both ends: Kansas City is neither French nor on the Great Plains, which begin a hundred miles west.

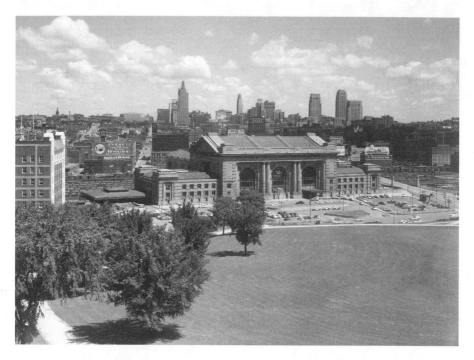

The view from Liberty Memorial, circa 1950. *Courtesy of Missouri Valley Special Collections, Kansas City Public Library, Kansas City, Missouri.*

Years ago, journalists compared Kansas City to Paris because of a sin-soaked nightlife. It was during the city's jazz heyday, usually defined as the period between the wars, the Pendergast era of corruption and vice that ended after the Democratic political boss was convicted of income-tax evasion. Tom's town became respectable. Some say, lifeless.

But while Paris of the Plains is a nickname of vague historical origin, from where I'm standing this morning in 1950, it's more than the sum of its parts. It feels as if it has transcended Boss Tom. The name sings, and the song is about—let's say—je ne sais quoi.

I see clues in the signage visible on the skyline. People here drink Falstaff and Country Club ("Kansas City's Largest Selling Beer"), but they also play Steinway pianos. They are high tech with their Admiral television sets, but they still travel by train with fantasies of the Old South ("Southern Belle to New Orleans"). It's a real city; it's a state of mind.

And because I'm a time traveler, I can see over the horizons of this city/state, bracketed by old city limits—the Missouri and Blue Rivers, Eighty-fifth Street and State Line Road—and by events symbolic of beginning and end:

the birth of its great monument to a war to end all wars and the death of its street railway. It spans sixty square miles and almost forty years, a period of growth from just more than 300,000 citizens to just under half a million. It's an era when the promotional tagline changes from "one of the most American cities"—its boosters mean "native-born"—to "the embodiment of aggressive Americanism"—as distinguished from Soviet communism.

And I can see beyond the muddy rivers, the sooty train sheds and the stinking stockyards. The perfumed ladies of this place shop at Harzfeld's Parisian. A fine hotel serves a one-dollar Parisian Surprise Luncheon. Parisian girls dance in the dreams of soldiers returning home from the war. Here's a vaudeville theater resembling the Paris Opera House; a war memorial inspired by the great Parisian monuments; and a thousand-foot-tall television antenna known as the "Eye-full Tower."

It's the town my family showed me as a young boy—a town of railroads, smokestacks and screened porches; cows and hogs; elm-canopied streets; and women in straw hats and old men in suspenders. It's got a zoo, a ballpark, an art museum, a fleet of cream-and-black streetcars and restaurants serving tomato aspic and gooseberry pie. It smells of lilacs and just-baked bread and something foul drifting in from the stockyards. Cicadas provide the soundtrack, accompanied by radio baseball and the *clip-clip-clip* of a lawn sprinkler.

It's also the town my straight-laced ancestors tried to ignore—the one Tom Pendergast helped create—a place of need and greed, anguish and demonic joy. It's a black and white place—that is, a place for whites there and, over here, a place for blacks. It's also a blues place, and the soundtrack might include gunshots, blue notes from a saxophone or the distant whistle of a night train.

So this is an attempt to know a place by excavating fragments of its time, many of them obscure or forgotten. They include white elephants, plastic bulls and swimming hogs; innocent bystanders, wayward sleepwalkers and doomed lovers; and yes, Rudolph Valentino, Lou Gehrig and Count Basie, but also Arthur Mann, Nancy Jordan and Albert Stewart.

Anything but lifeless, it's a real place where people work, play, love, hate and dream. They seem to know who they are, and they're happy to be Kansas Citians. For such a place, the name is a comfortable fit. Paris of the Plains: where grit meets grace.

Chapter 1
1910s–1920s

A New Phase of Life

The November morning was brisk, bright and promising, so I went underground.

It was not a protest against beautiful autumn days but a long-overdue, first visit to the National World War I Museum—a sleek twenty-first-century bunker beneath the 1920s-era Liberty Memorial.

Therein I saw spiked helmets, colorful tunics and hand grenades of many nations. I stood in a scale-model shell crater amid recreated sounds of battle. I read maps, timelines and charts of numbers upon numbers. I watched short films with ominous soundtracks. It was a blend of antique and high tech working hard to distill and animate years of events that snuffed an old world and birthed a new one. Even spread out over three hours, it was pretty overwhelming.

So I rode the elevator up and back, about ninety years, to the observation deck of the Liberty Memorial.

When the war ended in the eleventh hour of the eleventh day of the eleventh month of 1918, people here had already been talking for two days about the *Kansas City Journal*'s idea.

"The most practical and most happy suggestion for perpetuating the glorious achievements of the Kansas City, and Missouri and Kansas soldiers," the newspaper called it. "Erect a Victory monument in the station plaza."

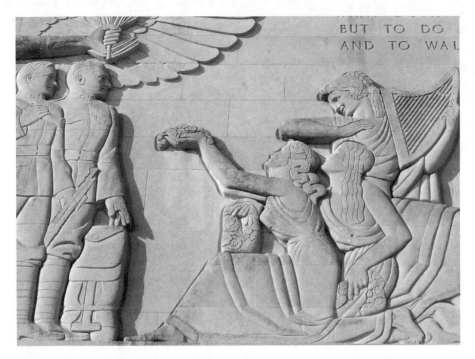

Detail of a frieze by Edmond Amateis on the north wall of Liberty Memorial. *Courtesy of the author.*

Civic leaders reacted: "A splendid idea indeed." "A glorious way for the people of Kansas City to express their appreciation of the soldier boys." "Let's not talk about it, but go right ahead and provide the monument." "What a grand thing it would be to do."

And there was another thread of thought: "It would beautify the city," said the *Journal*.

"The victory arch at dawn, the victory arch at noontime, in winter, in spring, in the fall, the victory arch at sundown, at midnight—what a pleasure for Kansas City and a privilege to gaze at its ever-changing beauty."

The architect of the city boulevard system took it another step. It was time to move beyond a preoccupation with commerce—it was time for art.

"I believe the memorial is but the beginning of further effort along the line of great civic enterprises," said George Kessler. "We are beginning to learn that there is another phase of life besides that of accumulating."

Funds for the monument came from private donations. The entire $2.5 million was raised in ten days.

The thing that now loops in my memory of the war museum is the audio alcove: a glassed-in cone of silence with softly colored lights and a sound system that plays snippets of old speeches, music and literature. It delivered that old world to me more immediately than any timeline or ersatz shell hole.

A keypad touch brought the voices of the kaiser and President Wilson; songs like "How 'Ya Gonna Keep 'Em Down on the Farm (After They've Seen Paree?)"; and excerpts from *A Farewell to Arms* and *The Great Gatsby*. There was also "In Flanders' Fields," the poem written by Lieutenant Colonel John McCrae, a Canadian who never it made it home from the war; I played that one twice.

It was a poem my schoolgirl mother memorized in the 1940s, when schoolchildren did such things. November 11 was called Armistice Day and veterans of that war—some missing an arm or a leg—sold carnations on street corners. The other day on the telephone, Mom proved she hadn't forgotten the verse that begins: "In Flanders Fields the poppies blow / Between the crosses row on row."

The November sun was shining up on the Liberty Memorial observation deck. With its commanding view of the city, this has long been an island of peace and a quiet place to reflect about lots of things: about the ironies of a war to end all wars; the poetry in thousands of poppies at the museum entrance and the lighted "torch" atop the memorial's two-hundred-foot tower; the fact that fewer travelers now first see this place from Union Station than from speeding cars on the section of Interstate 35 that slices through downtown; or the enduring, ever-changing beauty of the monument. As a war memorial, it is a source of civic pride and a portal to a younger city— awakening to a new phase of life.

GONE WEST

Sixteen hundred miles west of Union Station in the Los Angeles suburb of Monrovia, just off the Foothills Freeway, past the Wal-Mart and the Home Depot, inside the leafy and spacious confines of Live Oak Cemetery lies a headstone that reads: "Fritz E. Peterson, 1892–1931, 110 Engineers 35 Div."

It marks the final resting place for an Army veteran who returned home to Kansas City from the Great War and heard California calling him to become a chicken rancher.

Fritz Peterson's postcard. *Courtesy of the author.*

The 110th Engineers were maintenance workers. They dug trenches, built shelters, cleared battlefields and did other manual labor for the 35th Division of the American Expeditionary Forces in France during the summer and fall of 1918.

The Thirty-fifth Division saw only five days of action, in late September, in the Argonne Forest. In five days, the division advanced more than six miles, captured more than seven hundred Germans and suffered more than six thousand casualties, including more than a thousand dead. There's a story about a group of engineers working in the field who, attacked by Germans, fought with picks and shovels until their armed comrades arrived.

The 110th seems a natural place for Fritz Peterson to have landed after being drafted in 1917. His father was a maintenance engineer for the Kansas State School for the Blind in Kansas City, Kansas.

The Great War had its own language. Tank, camouflage, dogfight, dud and no man's land are terms that survive. Less remembered, perhaps, are to swing the lead, which means to malinger; to go west, which means to die; and some slang terms based on mispronunciations of French words, such as toot sweet from "tout de suite" and tray beans from "tres bien," To American doughboys, a Fritz was a German soldier. That must have made life interesting for Fritz Peterson.

They came home in late April and early May 1919, those men of the Thirty-fifth Division, most from Missouri and Kansas. Full trains pulled into Union

Station, sometimes with casualties and many missing arms or legs, in which case they would stop for Red Cross ladies to board with food and cigarettes, and then they would continue to convalescent hospitals somewhere. More often, the trains unloaded soldiers who would parade down Main Street to celebrate at downtown hotels, and then they would head back to the station for the last few miles to Camp Funston and a discharge.

A few weeks later, one of them wrote a message on a picture postcard of Union Station and addressed it to Chicago:

> *Dear Friend,*
> *Out of the Army and home by now, I suppose. Have much trouble getting out? How does it feel to be out? I say "tray of beans." Ha! Ha! I may go west.*
> *Best regards,*
> *Fritz E. Peterson*

OLD ROSE AND WHITE

It's one of those industrial landscapes—in this case, a concrete-and-razor-wire parking lot—that has swallowed whole blocks between the Crossroads and Historic Jazz Districts. No street signs exist here, but this used to be the intersection of Nineteenth and Tracy.

The area is so bleak that it's difficult to imagine anyone using the corner's bus stop, which is a vestige of the streetcars that stopped in front of the school that once stood here. On maps, it was sometimes identified as "Lincoln High School (Colored)."

Lincoln High was a predecessor of today's Lincoln Prep Academy, which sits on the hill at Twenty-first and Woodland. Actually, the old Lincoln curriculum was preparatory, as well. Students took classes in science, history and English literature. In the vocational-training department, they learned sewing, automobile repair, carpentry and bricklaying. Lincoln was well-known for music education.

Alumni included Walter Page, who played the upright string bass, later founded the Blue Devils and eventually became part of the famed rhythm section in Count Basie's Orchestra; and Charlie Parker, who used an alto saxophone to change the future of jazz.

Sidewalk detail at the corner Nineteenth and Tracy. *Courtesy of the author.*

The class of 1920 included Maceo Birch, who became a local entertainment promoter, later the road manager for the Basie Orchestra and eventually the head of the Negro band department at MCA records.

The summer before Maceo's senior year had been especially bad for lynchings in America; more than seventy were reported. During the school year, a black man was shot to death by a mob 140 miles east of Lincoln High in a small Missouri town. Another was hanged by a mob 120 miles south in a small Kansas town.

Here in Kansas City that year, children at an all-white elementary school put on a play, *The Pied Piper of Hamelin*. The play had a black character whose lines included: "But chile! Yo' should hab seen dem rats when dat Massa Pied Piper come in dis ar town. Da' followed dat man just like a lot o' white trash after a hunk o' lasses taffy."

At an all-white high school, the play was a comedy titled *Alabama*. A reviewer remarked of one character: "No one would ever have thought that George Pratt could make such a good 'nigger' as Decatur until he saw

'Alabama.' George's wobbly legs and 'nigger talk' brought much laughter from the audience."

At Lincoln, seniors reported their life ambitions to the school yearbook. Maceo Birch said he wanted "to own and operate a sporting goods store." For others it was to be a nurse; a milliner; an expert typist; an athlete second to none; a great businessman; or a first-class contractor, cornetist, cook, stenographer or dentist. They also aspired to be a bantamweight champion prizefighter, chief cook for Fred Harvey, cartoonist for the *New York Tribune*, leading soprano in Tolson's Jubilee Concert Company or president of Petty Business College. Others wanted to become a lawyer, oil magnate, drum major in a great band, vamp, old maid or Mrs. Miller. And some hoped to teach English at Wilberforce, travel with Bradford's band, have a fancy art shop on Petticoat Lane, own a first-class garage on Vine Street or live as royal as a king.

Under the bus-stop sign at Nineteenth and Tracy lies an old suggestion: a remnant of sidewalk and some brick pavers, cracked and broken. In 1920, Lincoln High was a handsome brick building. It's not known whether any member of the class of 1920, in his or her heart of hearts, ever imagined being sworn in as the president of the United States.

What is known is that the class colors were old rose and white; its flower was the sweet pea; and the class motto was *Vestigia nulla retrorsum*— no steps backward.

BLACKFACE AND A BLUE CHAIR

Down at the corner of Fourteenth and Main, where intensely bright lights turn night into day, the gray stone façade and celery-green dome of the new-old Mainstreet Theatre appear handsomely 1921, even as its marquee and innards are now brilliantly twenty-first century.

My favorite detail is the throwback sign—vertical lettering encircled by lights that rise like bubbles in a flute of champagne—which erases time, leaping over the shuttered years, over the Empire and RKO Missouri years to the period between the world wars.

The 1921 Mainstreet was the work of Rapp & Rapp architects of Chicago, who were responsible for theaters in more than twenty American cities, including the Paramount in New York and the Chicago in Chicago.

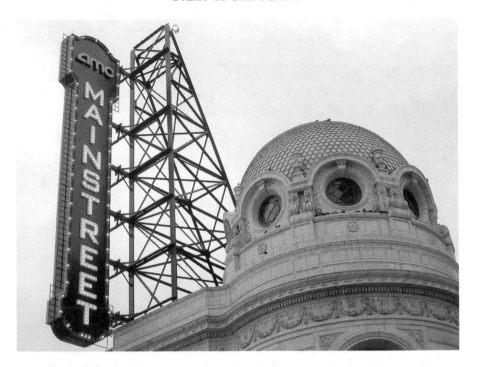

The Mainstreet Theater's effervescent sign. *Courtesy of the author.*

Today, their Mainstreet facade is a shell for a state-of-the-art, six-screen movie complex.

The original theater was built by the Orpheum theater circuit for the live spectacle of vaudeville—comedy skits, song-and-dance teams, animal acts, acrobats and jugglers—four times a day, as well as for movies, or "photoplays." It had 3,200 seats, an elevator, a motorized movable stage, plenty of restrooms and telephone booths, and lower levels housed an elephant cage, a seal pool and a nursery for small children. It was the largest theater in town, and it was bigger than its big brother on Baltimore, the Orpheum, which catered to a high-class, reserved-seat, subscriber-type audience.

The Mainstreet was intended for the masses, with open seating and continuous shows from noon to 11:00 p.m. It was perfect for businessmen on lunch hour, travelers killing time between trains and mothers shopping downtown with their children. Mom could drop Junior in the blue-and-white nursery while she caught the show.

Junior would find wooden blocks and stuffed animals, a rocking horse and a row of small wicker chairs, all white except for a single blue one, which he

would of course choose. When he sat in it, music would play, and when he got up to investigate, the music would stop. His puzzlement provided endless amusement for the adults in attendance.

The Mainstreet's opening day in 1921 aligned with the arrival in Kansas City of Vice President Calvin Coolidge, the World War Allied commanders and tens of thousands of war veterans assembling that week for the national American Legion convention and the dedication of the Liberty Memorial.

Hordes of them found their way to the new theater at Fourteenth and Main, seeing a show headlined by Eddie Foy and the Younger Foys. The bill included a comedienne, singers and dancers, bicycle riders, a dog-and-pony-and-monkey act and two brothers in blackface, advertised as "Impersonators of the Southern Negro." The photoplay feature was *After Midnight*, starring Conway Tearle.

The end of the original Mainstreet came at 3:20 one afternoon in early 1942, when the owners gave refunds to audience members and closed up. "Circumstances beyond our control," they said. The last live act to play under the Mainstreet signage was the Duke Ellington Orchestra.

Forty-some years later, when the theater was known as the Empire, the last movie I saw there was *The Cotton Club*. It was about the famous New York jazz club during the Harlem Renaissance of the 1920s, when the resident band was the Duke Ellington Orchestra.

Surely at least one Junior is still alive somewhere. I'd like to bring him down to see this new Mainstreet in its sleek Power & Light District setting and put him at a table in the gracious soul-food establishment upstairs across the street, at a window overlooking the theater's effervescent retro sign.

There, he might ponder the distance between his plate of catfish with collard greens and the old Mainstreet's blackface Impersonators of the Southern Negro.

And he might finally free his younger self from that haunting blue chair.

A Change of Heart

People once lived where Penn Valley Community College now sprawls. In the 1920s, apartments studded the south side of Thirty-first Street near Pennsylvania; modest buildings like those still found all over town that include three floors, two flats per floor and balconies overlooking the street.

Three floors, two flats per floor and balconies. *Courtesy of the author.*

When a man stepped from one of those apartment buildings on the morning of December 4, 1922, reporters from the local dailies were there with questions.

"I have nothing to say," said the man, whose name was Frank Warren. "It is nobody's business anyway."

Inside, the newsmen were met by the lady of the home, Mrs. Mary Warren, and her two houseguests that had just arrived from England, Miss Nancy Jordan, age twenty-three, and her two-year-old son, Francis.

"Men believe women to have a feline nature—that women are consumed with the desire to scratch and claw at other women," said Mrs. Warren, the thirty-one-year-old former wife of Frank Warren.

"We will be much happier when everyone forgets about us."

This is what Mary Warren and Nancy Jordan insisted was true:

Frank Warren, a U.S. Army lieutenant, had met Nancy Jordan, a bookkeeper, in post-war London in 1919. A friendship developed, and some months later, Miss Jordan gave birth to a boy. The father was an English soldier named John Smith, who disappeared.

Frank, hearing of Miss Jordan's situation, wrote about it in a letter to Mary, his wife of nine years. Mary, moved by the story, began a correspondence with the troubled young woman.

After Frank returned home to Kansas City, he and Mary divorced. It was the upshot of longtime incompatibility. Frank, an attorney at a fledgling downtown law firm, moved in with his mother. Mary, who came from money and had her own business interests, took the apartment on Thirty-first. They remained good friends; the divorce had nothing to do with Nancy Jordan or her son, Francis.

Mrs. Warren offered to pay passage to the United States for the unwed mother and child and to give them a temporary home in her apartment. Miss Jordan, fearing her situation would bring torment to her son if they remained in England, accepted.

Nancy said: "Mrs. Warren now says she will adopt my little boy and give me a place by her hearthstone. Was ever such ennobling altruism between two women?"

Mary: "It isn't altruism on my part. I simply want to do all I can for that little boy. I want to give him a home."

Frank: "Miss Jordan, herself, says I am not the father. If I were to say the child is mine, I would be challenging the truth of Miss Jordan's statement. Personally, I do not care what people say or what they think."

Upon arrival in New York, mother and son were detained at Ellis Island. Without a sponsor to assure they would not become public charges, they would be deported. Mary traveled to New York, paid a five-hundred-dollar-bond each and brought them home to Kansas City. Frank met them at Union Station.

Up here on Thirty-first Street, the 1922 view has changed. Instead of high-rise luxury condos, Mary Warren looked out on the St. Joseph's Orphan Home for girls. In place of the Firefighters Fountain, Nancy Jordan saw only the woodsy sweep of Penn Valley Park.

"It is so beautiful here—so very beautiful," Nancy said that December morning, which was her first in Kansas City.

One wonders what was said after reporters left, what expectations existed. There was Mary: dark haired, tall and slender in her rose-colored morning robe. And there was Nancy: small and pretty and fair-haired in a white housedress. Young Francis played with a new Teddy bear. His wide-set blue eyes matched those of his mother. His brown hair did not.

By the end of the next summer, Nancy Jordan was ready to return to London. Altruism had ended after the first week, and Mary Warren had remarried and moved away.

"I found there was no place for me," Nancy told reporters. "I felt that I could not afford to let myself and my child become a burden upon anyone."

She said she left the Thirty-first Street apartment, got a job and placed Francis in a foster home. Then she talked about the boy's father.

"Anyone can see the resemblance of Francis to Mr. Warren," she said. "I have letters at home in England in which Mr. Warren assured me we would be married in this country. If for no other reason than to give my child his name."

The father's support payments had dwindled over time, she said. And he had been urging her to give up Francis for adoption.

Frank said: "I have nothing to say. I don't care to reopen this case again, for anything I might say would not matter now."

Then a message for Nancy arrived at the *Kansas City Journal* from an Englishman in Chicago who had met her on the voyage to New York and followed her story in the papers: "Will you marry me and stay in America? Where can I see you? Wire answer."

Three days later, Nancy Jordan agreed to become Mrs. Claude Heatherington Clarke.

The groom said: "This has been the greatest day of my life. Kansas City is a great town."

Francis: "I'm going to have a new daddy!"

Nancy: "I thought all my love was wrapped up in my boy, Francis, but I was wrong. I'm sure now my heart is big enough for them both."

A FOGGY DAY

The northeast corner of Tenth and Grand is a chilly place. The old Federal Reserve Bank building—awaiting a new high-end, residential life—looms there, empty and imposing. Bulky planters and other security obstacles crowd the sidewalk needlessly now, since the bank has moved to new headquarters near the Liberty Memorial.

Still, it retains an oversize beauty and the elegance of a 1920s institutional structure. Six two-story pillars at the entrance are flanked by two allegorical bas-relief panels by Henry Hering: *Spirit of Industry*, with its sheaf of wheat and distaff, and *Spirit of Commerce*, with its torch of progress and caduceus

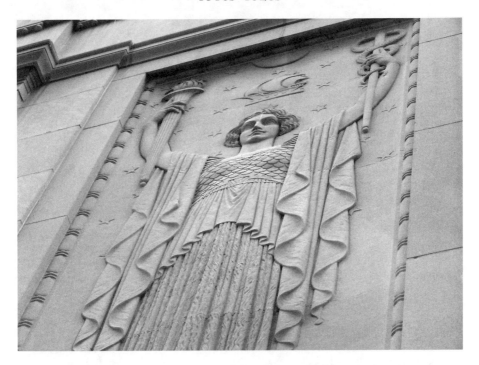

Detail of Henry Hering's *Spirit of Commerce* on the old Federal Reserve Bank at Tenth and Grand. *Courtesy of the author.*

of Mercury. Hering was known for his institutional sculptures in other cities, including Cleveland and Chicago.

You might imagine a visiting Chicagoan could feel almost at home on this corner.

One October Saturday in 1923, a middle-aged lawyer named George W. Pennington left his Dearborn Street office in Chicago, bound for a meeting at the Title and Trust Building around the corner on Washington Street. It was normally a two-minute walk. The day was fair in the Windy City, but somewhere on his walk, George W. Pennington entered a tunnel of fog and vanished.

At dawn four days later, a ground-hugging cloud slid into downtown Kansas City and snaked southward, eventually stretching from the Missouri River to Twenty-eighth Street, swirling and blending with smoke from factories and coal-burning locomotives.

From morning sunshine, commuters plunged into a dark soup of auto horns, streetcar bells and sightless pedestrians. Traffic crept along streets,

arriving trains stopped short of the Union Station sheds because of switching delays. Gradually, the pale disc of the sun warmed and dissolved the cloud, revealing abandoned autos and a streetscape familiar to most Kansas Citians.

On one downtown street, a well-dressed, middle-aged man blinked as if awakening from sleep. He saw things he'd never seen before.

That was not the Title and Trust Building he knew.

A block uphill—(hills?)—he asked a policeman about that large, pillared building on the corner.

It's the Federal Reserve Bank, said the cop, who wore a strange badge.

And this street corner?

Tenth and Grand.

No. That can't be right. There's no Tenth and Grand in Chicago.

Overhead, *Spirit of Commerce* smiled knowingly. She had stone-faced cousins in Chicago.

The bewildered man sat in the matron's room of the Nineteenth Street Police Station. Papers in his pocket identified him as George W. Pennington of the Chicago law firm of LeBosky and Pennington. Associates and relatives were en route to Kansas City to retrieve him.

He said this was his third memory lapse in several months since that taxicab accident. He recalled leaving the office to go to a meeting at the Title and Trust.

"I don't remember riding a train," he said. "In ten minutes, it seemed, Chicago had turned into hills and valleys and strange buildings.

"Nice town here, but too many hills and strange buildings."

BEAUTY AND THE BILLBOARD

I'm driving east on Independence Avenue, the ethnically diverse business thoroughfare in the Northeast neighborhood. Just past Benton Boulevard, traffic bottlenecks around a small pack of police cruisers huddled at the intersection of Indiana Street. At least one man is handcuffed and sitting on the sidewalk there.

As I squeeze past the Super Pollo Restaurante on the corner, I can see the 600 block of Indiana, a rather forlorn street of two-story residences in various stages of neglect. It's not clear that aesthetics and property values are neighborhood concerns.

At least, not by 1924 standards.

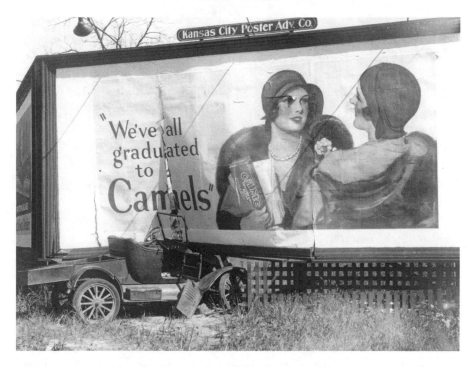

Billboards had long been an issue. *Courtesy of Missouri Valley Special Collections, Kansas City Public Library, Kansas City, Missouri.*

The Super Pollo occupies the former site of a vacant lot. In the spring of 1924, the lot was a sort of guerilla garden, an improvised neighborhood park in which several new flowerbeds in various shapes—squares, triangles and hearts—had been spaded and seeded by one man. T.H. Moore, who ran a small grocery next door on Independence Avenue, also planned benches for his garden. Neighbors called him "the park board."

People expected eventual construction on the vacant lot, and one day that April some men appeared with lumber. Stomping through T.H. Moore's flowerbeds, they dug holes and sank wooden posts. Surely this was the beginning of a new shop to join the cobblers, barbers, plumbers and others along Independence Avenue. Such was the common wisdom.

That is until one Friday when men returned with more lumber and began framing the posts. And then neighbors realized this was the start of a three-panel advertising billboard.

Billboards—and their perceived blight—had long been an issue in Kansas City. The city's official policy was to try to control them by refusing to issue

31

permits, but hundreds had gone up around town anyway. Many had gone up in recent weeks, perhaps in anticipation of the new mayoral administration.

Someone telephoned downtown and talked to the city's building superintendent. No permit had been issued for a billboard, and the lot's owner, who lived in Florida, had no knowledge of any construction.

That evening, after the workmen had left, people gathered in T.H. Moore's little park. Some brought hammers; others wielded loose boards. As they worked and the crowd applauded, a representative of the Thomas Cusack Company arrived and demanded they stop tearing down the company's sign. The neighbors drove him away.

"It is a detriment to our property, lowers its value and is a menace to the welfare of the community," said one.

On Saturday, the workers returned and rebuilt the framing. They added one new feature: notice of a fifty-dollar reward for helping convict anyone destroying the sign. And that night, four company men stood watch.

On Sunday, ten miles away near the southern city limits, another crowd gathered in the name of neighborhood pride. This was suburbia—the new Armour Hills development—and the occasion was the dedication of a new fountain in a grassy island near Sixty-ninth Street and Wornall Road.

It was to be the focal point of the planned Armour Center: a cluster of shops, a movie theater, a filling station and a church situated near the new station along the Country Club streetcar line. There were new trees, honeysuckle, and ivy-covered stone walls, which were all part of the developer's commitment to the protection of property values.

The fountain, a piece of white Venetian marble commissioned by the developer, J.C. Nichols, depicted an American eagle and two children. The sculpture, said the Nichols Company, symbolized the American home, as Armour Hills "typifies true patriotism and home life."

It was "not only for the residents of Armour Hills but for all Kansas Citians who love the beautiful."

Hundreds of Kansas Citians who loved the beautiful gathered that night at the corner of Independence and Indiana. About a dozen carried axes and saws and attacked the rebuilt billboard with renewed vigor. The sign company's guards were nowhere to be seen.

Piece by piece, the sign became a pile lumber; cans of oil and kerosene appeared. Just before the match was struck, a final piece was flung to the top of the pile: the fifty-dollar reward notice.

A neighbor said, with certainty, "If they put that structure back up we're going to burn it down again."

Wheeling south, I drive the ten miles from Independence Avenue to Sixty-ninth and Wornall and pull over near a small grassy neighborhood park and its marble fountain.

People walk and jog where streetcars once ran; houses sit where the Armour Center would have been had not early residents voiced concern about what shops would do to their property values; and the Venetian-marble eagle and children have been replaced by a different, aquatic-themed sculpture, something not obviously symbolic of anything more than neighborhood splendor. The only sound is a single lawnmower—the droning harbinger of summer.

It makes me think of a long-forgotten vacant lot across town and what might have been: a bench, a heart-shaped flowerbed, maybe some hollyhocks.

TONIGHT AT THE ORPHEUM

It was a ticket stub, about one inch by an inch and a half, a remnant of some New Year's Eve in the orchestra section at the Orpheum. December 31 fell on a Thursday, but what year? An Orpheum Theater operated in the 1200 block of Baltimore from 1914 until it was torn down in 1962, so I took a stroll through some of the possible Thursdays.

Tonight at the Orpheum, celebrate with a Vaudeville revue starring long-legged Charlotte Greenwood, the sensational comedy hit of the season.

Elsewhere, hotels and clubs have reservations for six thousand at $6 to $15 per couple for dinner and dancing to Tike Kearney's Arcadians or the Shadowland Serenaders. Horns and funny hats are included, not to mention a detective, a government man and a tabletop sign reading: "The reservations made for New Year's Eve in this room were with the strict understanding that there would be no violation of the liquor laws." Although the local bootleg is said to be hair tonic and perfume with some of the blindness boiled out, a quart of gin will cost $4 and a case of whiskey will run you $175.

Streets will fill with ladies in evening gowns and orchid corsages, and men in tuxedos and silk mufflers and black derbies. Just before midnight, steam locomotives and factories will open their whistles in the wintry cold, joining claxons and sirens across town. In the Pompeian Room, Father Time will

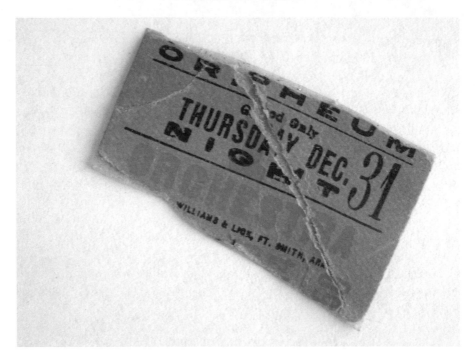

A remnant of some New Year's Eve. *Courtesy of the author.*

shuffle out—a large clock will open to reveal a dancing 1926. In the traffic crawl at Twelfth and Main, taxi drivers will backfire their motors. Revelers will cling to the tops of buses, tooting paper horns. One car will carry a full orchestra. Two young men in dinner jackets will hand out keys to the city. A gray-haired man will speak to a young woman in a green dress with a drunken escort: "Lady I don't know you and your friend but I gotta car and it's going your way."

Tonight at the Orpheum, celebrate with the Woodward Players in *As Husbands Go*, a comedy about two women from Dubuque who travel to Europe and contemplate divorce.

Elsewhere, Jack Collins and his Eleven Rhythm Aces will play "Snappy Music" at the Aladdin Hotel Roof Garden, and there'll be "Beautiful Girls, Plenty of Favors and Plenty of Surprises." The White House Tavern will offer Walter Page and his Thirteen Blue Devils, and a "Delicious Breakfast" after 5:00 a.m. Dance 9:00 p.m. to 5:00 a.m. at El Torreon, with "Two Bands For this Big Whoopee Occasion!" At Nichols, expect a "Hotsy Totsy

Time, a Good Floor and a Red-Hot Orchestra." And Chic's Fourteen Pla-Mors will play the Pla-Mor Ballroom from 10:00 p.m. until 4:00 a.m. The Pla-Mor promises "Thousands Will Greet 1932 Prosperity!"

Partygoers will pay a five-dollar cover. A woman will lose her diamond-and-sapphire wristwatch. Police will raid a man's home, arrest him and confiscate three and a half pints of liquor. Just before midnight, revelers and autos will choke the junction of Twelfth and Main with autos backfiring, drivers hollering and doorway merchants hawking paper hats and noisemakers at reduced prices. Cops will blow whistles; someone will fire shots in the cold night air; boozy rumble-seat riders will wave and shout at the sidewalks: "Happy near you! 'Pressions shover!'"

Tonight at the Orpheum, celebrate with "The Show You'll Talk About Long After You've Stopped Laughing!" Cary Grant and Ginger Rogers star in *Once Upon a Honeymoon*. "Extra Special! Walt Disney's Donald Duck in *Der Fuehrer's Face*."

Elsewhere, thousands will flock to parties at Municipal Auditorium, the Hotel President, the Phillips, the Muehlebach and the Continental or to Milton's Tap Room, where Julia Lee is at the piano. There's also the Folly Burlesque for the Silk Stocking Revue; and the Tower Theater for Billy Rose's Diamond Horseshoe Revue, with Gilda Gray, "the Queen of the Shimmy," and "America's Most Beautiful Girls." Special streetcar and bus service will run until 3:00 a.m.

Police will block traffic along Twelfth Street. Thousands will be wearing the olive drab or navy blue of the armed services. They'll be dancing at the Canteen, streaming in and out of the Officer's Club, nibbling doughnuts at the USO, standing three deep at the Cabana Room bar and cajoling civilians for a bottle when MPs shut off their alcohol at 9 o'clock. Just before midnight in the Terrace Grill, an old man will drag a scythe out of the way of a bouncing baby dressed as 1943. A soldier and a sailor will stand up and the crowd will sing "Auld Lang Syne" and "Praise the Lord and Pass the Ammunition" and the national anthem.

Outside, the mild night air will fill with confetti, whistles, horns and firecrackers. Celebrants in Hawaiian leis and paper hats will stop to pet a pair of white puppies for sale and toot horns at them. Five soldiers will surround a girl in a blue coat, pass her from one to the next and steal kisses. A young civilian will grab a passing servicewoman and strong-arm her and shout at the night: "Whooee! I always wanted to kiss a WAC!"

Tonight at the Orpheum, celebrate with "The First Sweeping Adventure Entertainment In Cinemascope" with *King of the Khyber Rifles*, starring Tyrone Power.

Elsewhere, dance till 5:00 a.m. to the Red Hot Scamps at the Mayfair Club. Enjoy the "Keyboard Varieties of David Chody" at the Zephyr Room; Scotty Lynn on organ in the Zanzibar Room; Dusty Williams and his Boys at the Tick-Tock Lounge; Cliff Sheperd and his Ozark Crest Riders at the Rainbow Club; and Gus DeWeerdt, "Famous TV Entertainer," at Sans Souci. "No Reservations Necessary. No Cover Charge, No Tax, No Minimum."

Just before midnight, thousands will pour from hotel lobbies and clubs and cars, bound for Twelfth and Main, a blend of light jackets and military uniforms and black ties and gardenia corsages. The mild night air will carry the bleat of toy horns, the rattle of cowbells and the pop of balloons and fireworks. Confetti will be tossed; women will be kissed; and teenage boys will scuffle. A gray-haired man will ask four cops to dance with him in the street. Shortly after midnight, the crowd will melt away. Down at Union Station, people in cone hats amid a forest of balloons will hear loudspeakers crackle: "Attention please: the Kansas City Terminal Railway Company wishes you a happy new year for 1954."

A Free Man Checks In

The mezzanine of downtown's Hotel President is not exactly as it was when the hotel opened in early February 1926—the recent total renovation did not bring back the shops and beauty parlor; the library with its stock of the latest fiction by Sinclair Lewis, F. Scott Fitzgerald and Edgar Rice Burroughs; or the WDAF radio studio that piped popular tunes to all 453 guest rooms.

Still, the ornate chandelier and fluted columns say 1926, and from the mezzanine railing it's not hard to see a tall, slender Irishman in a dark blue suit, gray tie, plaid silk socks, brown oxfords and gray homburg striding across the marble floor of the lobby one morning in late March of that year, heading for the elevators.

"That's him," says an excited bellboy. "That's Big Tim!"

Timothy D. "Big Tim" Murphy has arrived, fresh from three years in the Leavenworth slammer.

At that point, Big Tim's resume included newsboy in Chicago's stockyards district, gang leader, Illinois legislator, union boss, racketeer and convicted

The Hotel President. *Courtesy of the author.*

felon. This last distinction stemmed from a $360,000 mail robbery at Chicago's Dearborn Station in 1921. As mastermind, he was sentenced by Judge Kennesaw Mountain Landis to six years in Leavenworth. With an appeal and time off for good behavior, he served only three, adding to his resume the duties of pipe fitter in the prison power plant.

Kansas City hadn't figured much in Big Tim's original plans. His wife, Flo, had been visiting him from Chicago every two weeks during his prison time. But she disliked the bathtubs in a Leavenworth hotel so she'd been staying in Kansas City and hiring a taxi to drive the sixty-mile round trip so she could see Big Tim.

Flo and a traveling companion were waiting in the taxi parked outside the penitentiary gate at 6 o'clock that morning of his release, having already delivered new clothes to her husband the day before. He refused the suit the prison provided all freed prisoners, as well as breakfast and the free ride.

"Get on away," said Big Tim, in his new duds, to the guard at the gate. "You stink. Damn that hell-hole and everyone in it."

Then he turned to reporters. "I'll be in Kansas City until tonight," he said. "Look me up there if you've got anything to say or ask, but I don't want to waste a lot of time 'cause the missus and I have some visiting to do."

In those pre-Drum Room days of Prohibition, the President had a drug store at its corner of Fourteenth and Baltimore and a separate lobby entrance on Fourteenth. That's the one the Murphy entourage used that Friday morning, and they immediately went up to Mrs. Murphy's suite of rooms on the ninth floor and ordered breakfast.

The plan was to board an overnight train for Chicago later in the day. But Big Tim learned authorities planned to greet him upon arrival with an arrest warrant. It was something about a $10,000 fine levied with his conviction that he had yet to pay. Since there was to be a band, banners and a bunch of Big Tim's pals there to welcome him home, an arrest would be humiliating. He decided to extend his stay in Kansas City.

So Friday and Saturday, Big Tim held court in suite 941 to 943, talking with reporters, receiving friends and talking on the telephone. He said he wanted to get back to Chicago and see his mother and his nieces and nephews, go horseback riding and travel to Europe with his wife.

"I want to get back to my old job of fighting for the men and women who do the work of the world," he said. "I've been doing that for twenty years, and I expect to keep at it until I die."

On Sunday morning, he sent his wife home on the train to run interference on the arrest business. Then that night, he boarded a Santa Fe train for Chicago, saying he had decided to "go ahead and get it over with."

I like to imagine Big Tim up in his suite on the ninth floor, late on a Kansas City Saturday night, stretched out on the sofa under the portrait of President Calvin Coolidge, listening to the radio broadcast from down in the mezzanine studio. WDAF's *Nighthawk Frolic*, tunes of the day drifting out of a tinny speaker—maybe Ben Bernie's "Sweet Georgia Brown" or Vernon Dalhart's "The Prisoner's Song."

> *Now if I had wings like an an-gel*
> *O-ver these pri-son walls I would fly*
> *And I'd fly to the arms of my poor dar-lin'*
> *And there I'd be wil-ling to die*

When he arrived in Chicago, Big Tim Murphy was not arrested.

Two years later on a warm night in late June, he answered the doorbell of his bungalow on Chicago's far north side. No one was there, but a car with curtained windows pulled up and a machine gun put an end to Big Tim. His murder was never solved.

RUDY'S LAST LAYOVER

The tracks under the Main Street viaduct near Union Station carry heavy traffic, primarily freight. Two passenger trains run back and forth daily to St. Louis, and another stops once in each direction traveling between Chicago and Los Angeles.

It's a long way from the years when a person standing on the viaduct could watch hundreds of passenger trains pull under the sheds every day, and from the September morning when hundreds of people lined the railing, waiting for one particular train from the east.

On the day he died, in the summer of 1926, the thirty-one-year-old man born Rudolph Guglielmi was on horseback with a beautiful woman, riding into a desert sunset in downtown Kansas City.

Patrons of the Royal Theater sat that afternoon in the flickering light of *The Son of the Sheik*, dabbing eyes with handkerchiefs. "Doesn't it almost frighten you to think that he is dead and we see him moving before us on the screen?" said one.

Tracks under the Main Street viaduct. *Courtesy of the author.*

Outside on Main Street newsboys sang out their early editions: "All about the death of Rudolph Valentino!"

In those days before antibiotics, Valentino succumbed to infection after surgery for appendicitis and a gastric ulcer. In New York to promote *The Son of the Sheik*, he was stricken in a hotel room and spent his last week in a hospital room, surrounded by flowers.

Police struggled to control tens of thousands who assaulted the Manhattan funeral parlor in the rain to get a two-second glimpse of him in an open casket. Plate glass windows shattered; shoes littered the streets; and women fainted.

Those who knew him characterized him as a great artist; a flame of genius; an excellent actor and a fine fellow; a very dear friend and a man of charm and kindliness; one of the screen's greatest lovers, but one of Hollywood's most perfect gentlemen; honest and sincere; a real man.

"I felt somehow that such a brave, intense living spirit could not die," said one actress.

A Hindu mystic declared that anyone on the proper spiritual plane knew only the body was gone. "If he was beautiful, it was his soul," said the mystic. "And it lives, so why all the mourning?"

Like most movie stars, Rudolph Valentino had spent time in Kansas City, if for no other reason than that the transcontinental train he was riding had an hour-or-so layover at Union Station.

On one such stop not long before his death, a local reporter had found Valentino sullen and withdrawn as he wandered the cavernous lobby of the station, hands in pockets, hat pulled down low, ignoring women who recognized and approached him. Finding refuge outside in the parking lot, he complained.

"I hate to be seen in public. They've made me rich, but they've made me miserable," he said. "I'd lick anybody, or let them lick me to prove that I'm a man. I'm tired of being the sheik. I'm tired of the whole business."

The reporter decided the source of irritation was an editorial in a Chicago newspaper. The editorial had blamed Valentino for subverting American masculinity, calling him a "pink powder puff."

At 10:30 a.m. on September 4, twelve days after Valentino died, the Rock Island Railroad's Golden State Limited chuffed slowly toward the Union Station train sheds on track 14, its steam locomotive stopping just under the

Main Street viaduct. Maybe fifty onlookers peered down from the railing on Main. The public had been banned from track level, but several people ran along the platform anyway.

Between the dark engine and its regular consist were two special cars. The first bore Valentino's body in its solid bronze casket with sterling-silver overlay and a fresh array of lilies, delphiniums, gladioli, palms and pink and yellow roses. The second carried an entourage of intimates, including his brother, his manager, and his lover, screen actress Pola Negri.

Messengers carried a few telegrams to the train. A bystander offered five dollars for the chance to deliver them to Pola. Inside her drawing room, the black-haired Pola sent a telegram to her chauffeur in Los Angeles, ordering a blanket of pink roses for the casket, seven feet by three. She looked as if she had been crying for twelve days. She wore a black robe over peach silk pajamas and black-satin slippers and held a large photograph of Valentino. Her chin trembled; her voice was weak.

"My grief does not permit me to speak at any length," she said. "There was never a formal engagement. There was no date set. It was just an understanding arising from a beautiful friendship."

The brother announced he was changing his name to Alberto Guglielmi Valentino. The manager said final funeral arrangements were pending. Up in the station lobby, some young flappers were asked whether they were trying to see the Valentino train.

"Heck no," said one. "My sweetie's coming in on the 11:10."

It was said that Valentino had intended to stop awhile in Kansas City on his return from New York to Hollywood. Apparently he believed he had done a disservice on some previous visit.

"I made a mistake, and the best way to rectify a mistake is to ask to be forgiven," he was quoted as saying. "I want to stop there long enough to meet the people and try to make them like me."

At 11:20 that morning, the Golden State Limited inched out of Union Station and headed west. Up on the Main Street viaduct, the crowd of fifty had become three hundred—plus the lingering soul of a man hoping to be forgiven.

Perhaps he was recognized by anyone on the proper spiritual plane.

A STREETCAR NAMED HOPE

The corner of Twenty-second and Grand lies wedged between the contemporary glass and steel of Crown Center and the rejuvenated brick of the Crossroads District. Years ago, you could stand on this corner and see Union Station and the rows of train sheds that sheltered arriving and departing passenger trains. The train sheds are long gone, and a large office building now blocks the view of the station.

Across the street, along the edge of Washington Square Park, a sidewalk running west toward Liberty Memorial and the train station hugs a concrete balustrade above the rail yards. Surely it's the same path walked by that woman and her six children on the first day of 1927.

There was a streetcar stop here on Grand for the Rockhill–Northeast line. The woman and her kids, all under the age of twelve, waited here. When a maroon streetcar rattled along, the seven of them climbed aboard. It was a fair New Years Day, with temperatures in the forties.

She told the conductor she had no money; she said they'd spent the night on benches in Union Station after riding a train to Kansas City, which was as

A sidewalk runs west toward Liberty Memorial. *Courtesy of the author.*

far as her funds would take them. Someone at the Travelers Aid booth told her to take this streetcar to the Jefferson Home for Women and Children, on Garfield Street, and wait there for money to be wired.

She was trying to get to her parents' home in Kansas. A week before, at Christmas, her husband had abandoned them.

A headline on a small story in the next day's *Journal-Post* made the conductor a hero. The story told of him paying the family's fares and then passing a hat among the streetcar's thirty passengers. At a time when a loaf of bread cost a dime and a pound of beef cost forty cents, the passengers put six dollars in the hat.

Later that day, money arrived from the woman's parents, and the family continued the journey home.

Standing here now at Twenty-second and Grand, I'm thinking of a particular passenger on that streetcar, "an elderly woman," in the newspaper account. I see her listening to the conductor explain the situation. She looks at the faces of the children and then at the mother. Maybe she stares out the window and down this sidewalk that leads to the train station. Maybe she's imagining herself in a tough situation like this—or remembering one.

The story said she put $1.50 in the conductor's hat. It was all she had in her purse.

WASHED AWAY

A springtime Kansas City thunderstorm can be simultaneously frightening and fascinating. Downtown offers its rooftops and hilltops as ideal places to watch a distant thunderhead build, blacken and blow into town, flashing its lights and dragging curtains of wind and rain across the city.

Typically, it arrives from the southwest in the afternoon, with the warming of the sun. But weather here can be ornery.

And so, with rain streaking my windows and Randy Newman's "Louisiana 1927" in my head, I'm thinking of the day a cloud, maybe four miles high, billowed out of the northeast just after dawn.

The spring of 1927 had been a wet one in Kansas City, maybe five inches beyond average. But the rivers were normal and it was nothing like what they were getting down south and east, where rain had been falling since the previous summer.

Weather here can be ornery. *Courtesy of the author.*

It seemed every morning the papers told of some new break in the levees along the lower Mississippi, more people lost, thousands more homeless in refugee camps or, worse, clinging to treetops or the roofs of house-islands in a raging brown sea. There was rain and more rain, wind and hailstorms breaking windows of every house in some little Arkansas town or flattening a wheat field and drifting two feet deep in Oklahoma. Kansas City got nothing like that.

And there was nothing surprising about waking up here under a cloud on May 7, a Saturday—just another workday morning for most. About a quarter to 8:00, the sky darkened. Lights came on in houses and apartments; motorists switched on headlights. People at breakfast glanced down at the newspaper's forecast: "Unsettled weather…a possibility of light showers."

The air was perfectly still. The cloud opened. The water fell heavily.

On the ground, it gathered itself, rushed to the nearest gutters, swelled into widening streams and climbed curbs onto sidewalks. Businessmen waded ashore from streetcars, carrying stenographers to the higher ground of corner drugstores.

It spilled into basements, knocking out electric power and shutting down elevators. Carts in the City Market toppled; radishes trailed in the wakes of tomatoes.

It scoured the streets, lifting old wooden paving bricks from their sand beds, sending them bobbing along Main and onto the running boards of cars parked in the Union Station plaza, which had become a lake that greeted arriving passengers.

It raged down Walnut, choking storm drains, eddying in muscular circles and halting traffic. It overtook the intersection of Thirteenth and Jackson with ten feet of water, creating a two-block logjam of streetcars with anxious faces at the windows.

In ten minutes—from 8:20 to 8:30 a.m.—one inch of rain; another inch and a half fell by just after noon. As it lessened, storm drains caught up, and the water slowly receded. An underground torrent headed for the river.

Out east near the Sheffield Steel plant, three construction laborers hurried to remove two pumps from a new sewer project on the Blue River. The river was rising and they could hear a roar building in the huge sewer, but they felt protected by a temporary dam.

When the wall of water hit, the dam broke. The three men were swept into the river. Two grabbed floating lumber and struggled to shore. The third, a twenty-nine-year-old newlywed named Albert Stewart, was hit in the head by a collapsing scaffold and disappeared under the surface.

That May, tornadoes and straight winds killed dozens and blew down houses and barns in Missouri, Kansas, Arkansas, Texas, Indiana, and Michigan. An earthquake on the New Madrid fault rattled towns in several states. Heavy snows blocked roads on the high plains. In June, a comet passed close to the earth.

In August, a member of the Adventists declared, "Recent cyclones, bad storms, volcanoes, eruptions, falling meteors and political turmoil indicated the approaching end of the world."

The bloated lower Mississippi and its tributaries pulled back from Arkansas, Mississippi and Louisiana. Then, in late September, the rains returned to Kansas City. In one weekend, nearly six inches fell and the Blue River ran over its banks. Thousands of people rode out to Swope Park to watch trains—engines snorting steam—plow through standing water.

Downstream, the Missouri surrendered the remains of Albert Stewart, still clad in his leather jacket and raincoat.

Now, listening to "Louisiana 1927" or some delta blues like "High Water Everywhere," I might imagine Albert Stewart is returning to town, as if his spirit had continued down the Missouri into the swollen Mississippi and south, maybe a week's journey to the delta, some more days to Louisiana and on to the gulf, mingling and melding along the way with spirits—officially 250 dead, but there were surely more buried in the mud—of all those washed away.

INDEPENDENCE DAY

The dog and I were walking along a stretch of brick storefronts on Seventeenth Street. A white truck, double-parked, delivered crisp linens to a vegetarian cafe with bud-vase flowers in the window. At the corner of Summit, an athletic blonde in lime-green shorts jogged slowly past more boutique food, past modest Victorian houses and a sleek new home of concrete-and-glass design, past weeds and rosebushes and past a scruffy guy draining water from a fishing boat on a trailer.

A breeze carried the sound of metal on metal: battered hubcaps and other silvery junk hanging from a chain-link fence along with animal bones and smiling ceramic heads. Next door was a deserted, yellow-brick school—West Junior High—its stately windows sealed with plywood; it is not a place that inspires celebration now. But one summer evening in 1928, when this neighborhood was known as the "Mexican colony," the school auditorium hummed with life and the celebration of Mexican independence.

It was September 16, the 118th anniversary of the cry of Don Miguel Hidalgo y Costilla of Dolores, who rang his church bell and urged his followers to revolt against the Spanish colonists: "My children, a new dispensation comes to us today. Will you receive it? Will you free yourselves?"

This day, they gathered on the hill at Twentieth and Holly Streets in Observation Park. There was a parade with floats decorated in red and white and green, with a king and queen cheered by revelers in shawls, brightly colored skirts, embroidered vests and straw sombreros. They sang the Mexican and American national anthems. A stringed orchestra played. There were footraces and boxing matches and speeches, tamales and enchiladas and ice cream cones. And there was the revered host, Dr. Nicholas Jaime, the community's mentor, greeting celebrants with a cheerful "Buenos dias!"

West Junior High School. *Courtesy of the author.*

The Mexican colony had existed since at least 1911, after the start of the Mexican revolution, when the first extended family arrived. Dr. Jaime came three years later, in time for the influx of immigrants after the world war when the number grew to thousands. He had attended the University of Michigan and the University of Illinois medical school, and then he headed a Mexico City hospital. He landed here when visiting a friend who asked him to treat a sick person.

"Then I stayed on a few more days, looked over the Mexican situation here," he remembered later. "And seeing the need of medical attention in the colony, I decided here was my life's work."

At the time, many immigrants were living in poor, unsanitary conditions in overcrowded shacks or damp basements. They worked in packing plants or rail yards, had unskilled jobs or no jobs at all. Most were illiterate and spoke no English. No clinics or churches would accept them.

With others, Dr. Jaime had worked over the years to improve their quality of life. Now there were churches and health clinics, Boy Scouts and Camp Fire groups and a community center with classes in homemaking and in reading and writing English.

"If we can make good Mexican citizens, we can make good American citizens," said the doctor.

From Observation Park, the celebration moved to the auditorium of West Junior High at Twentieth and Summit Streets. A stringed orchestra played; people danced; and more speeches were made. Then, Dr. Nicholas Jaime got up; he looked around at the people in their colorful costumes, and he must have felt satisfaction at how far they had come.

He knew there was work ahead—and difficulty—but he could not have foreseen the stock-market crash a year later or the long, hard times that followed. The great loss of jobs and the political turmoil that would lead to hundreds of thousands of Mexicans—including many U.S. citizens—being shipped back to Mexico.

Whatever lay ahead, he knew what he wanted to tell these people that night. Speaking in his native language, he urged parents to put their children in public school and for the adults to attend night school. The only way to a better life was through education and hard work, he said.

It was Independence Day, and the spirit of Don Hidalgo filled the auditorium of West Junior High. My children, will you receive it? Will you free yourselves?

HERE, OUT WEST

Things are mostly quiet these days down at the former City Police Station no. 4 in the Crossroads District, once better known as the Nineteenth Street Station, which was a stop on the beat of a young *Kansas City Star* reporter named Ernest Hemingway.

The two-story, triangle-shaped building, built in 1915, got a partial makeover a while back in anticipation of becoming a Cuban-themed nightclub. The club never opened, but the ornate exterior—stucco with Craftsman-style woodwork—still wears the yellow and scarlet paint. Columns frame the old entrance, which is now home of the Hemingway Gallery, and in the early years they surely welcomed a variety of characters—usually the two-legged variety.

So the cops were probably as unprepared as anyone in town on July 24, 1928, as they were booking a man for drunkenness at the second-floor desk and a bellowing Hereford steer charged up the stairs from the street and plunged into the room. It was after midnight in Kansas City.

The former City
Police Station no. 4.
Courtesy of the author.

Five miles south, near Sixtieth and Oak in Brookside, a man awoke, looked out a window and saw a large animal standing in his flowerbed. It appeared to be a cow.

At dawn a man left his east-side home to begin his newspaper delivery route. If not for the fox terrier chasing two white-faced steers down Cleveland Avenue, it might have been the start of a forgettable summer Tuesday.

The Kansas City Stockyards once sprawled over more than two hundred acres between Twelfth and Twenty-third Streets, straddling the state line in the West Bottoms. The temporary home to thousands of mostly doomed animals, at one time they comprised a mud-and-wood labyrinth of 4,200 cattle pens, 700 hog pens, 400 sheep pens and chutes connecting the pens to railroad platforms and to big packinghouses with chimneys that belched foul-smelling smoke into the wind and across town. Fifteen large barns held mules and horses for buyers to examine. And for the buyers and the cowboys who worked the pens, there were hotels, offices, cafes, harness shops and banks. It was almost a city within a city, second in size only to Chicago's stockyards.

Thousands of animals arrived daily from farms and ranches throughout the Plains and Southwest, sometimes as many as 30,000 to 40,000 cattle in a single day. One day, during World War II, brought 57,642 head of cattle to the stockyards for sale to buyers from around the country. Often there were several varieties: slender, shorthaired cattle from near the Gulf of Mexico; large, red, longhaired cattle from Montana; and white-faced Herefords from Kansas and Missouri.

In 1928, more than 8,000,000 animals funneled through the Kansas City Stockyards. Nearly 2,000,000 of those were cattle. Of those, some 150 Hereford steers and heifers were selected one July day by a buyer from Ohio and loaded onto four cars of an eighty-two-car Santa Fe freight train. Around midnight, the train pulled out and crept slowly east through town.

Just past the McGee Street Viaduct, a faulty switch derailed the locomotive. A second engine at the rear of the train shoved nine of the cars into a pileup, including three cattle cars. The cars broke apart and eighteen animals were killed. The terrified, wailing others blinked into the darkness and lit out in all directions.

The cattle scattered from Merriam to east Kansas City, from the river to Brookside. Human reaction varied.

Men in a parking garage at Twelfth and Oak stood well back and tried to coax a steer before he broke through a glass door, gored several automobiles and crashed through a plate-glass window. A crowd chased an animal into a bookstore at Eighth and Grand, where he knocked over bookshelves before running back into the street. A streetcar operator stopped his machine and examined a twisted bumper after hitting a steer at Thirteenth and Main. The steer got to his feet and trotted down Thirteenth.

The drunk at the Nineteenth Street Station fell to the floor as the charging animal ran past him, scattering furniture and policemen, and out another door. Out at Sixtieth and Oak, the Brookside man hopped into his Ford, revving the engine and honking the horn at the beast in his flowerbed.

A man, newly arrived from Alabama, saw another steer chasing people through Parade Park at Fifteenth and the Paseo. He grabbed for its horns, twisted its thick neck and rode it to the ground. A policeman helped tie the animal to a tree.

A pair of stockyards cowboys on horseback lassoed several auto bumpers before finally roping two animals near Twenty-ninth and Benton Boulevard. More cowboys corralled a small herd near the sphinxes at Liberty Memorial. Crowds surrounded exhausted animals tied to sidewalk poles at Sixth and Delaware and at Twelfth and Baltimore outside the Hotel Muehlebach.

Amid screams, the night agent at Union Station followed one creature into the women's waiting room. Chasing it back into the lobby, he took hold of the horns, twisted and let the slippery, polished marble floors do the rest.

"I've been out West," he told a red cap.

The roundup took a couple days, as did the cleanup down on the railroad tracks. The freight train also had been carrying butchered beef, eggs and fruit. Onlookers stood on the McGee Viaduct and watched a derrick lift the damaged locomotive and boxcars. Even then, the onlookers must have represented both viewpoints:

Those who in coming years would look at the stockyards and know what developer J.C. Nichols meant when he said there wouldn't have been a Country Club Plaza if not for the livestock industry.

And those who would only wish the mud, the stink and that image would go away. The image that would cause, for instance, a New York reporter to wonder in print, "Why would anyone voluntarily visit a place once called 'the capital of cowtowns?'"

They're the ones who would one day stand on the downtown bluffs and look out over the wide-open, odorless spaces of the West Bottoms and feel no loss.

SNOWFALL OF THE AGES

I was standing at a Crown Center bus stop in the latest of several early winter snowfalls, wondering whether this was something like life in, say, Saskatoon (known to Canadians as Paris of the Prairies). Conversations around town had been variations on a theme: Someone had been in Kansas City for X number of years and had never seen winter like this. Forecasters had the mercury plunging toward zero and beyond, with a howling wind.

There were no complaints at the bus stop. The snow hushed the rush-hour traffic. White lights shimmered in bare branches. A Zamboni machine refreshed the nearby ice rink for skaters. A few stylish pedestrians were dressed for October, while most others wore layers of foul-weather gear. The electronic sign announced a delay for the MAX bus.

"Another will come along eventually," said one cheerful, bulky woman in the shelter.

I waited outside, gathering snowflakes like a statue, drifting past Saskatoon to a January in Kansas City before wind-chill factors, road salt or four-wheel drive.

It's a week past your New Year's Eve celebration, when you were perhaps warmly toasting 1929 with a glass of bootleg hooch while outside it was snowing four inches.

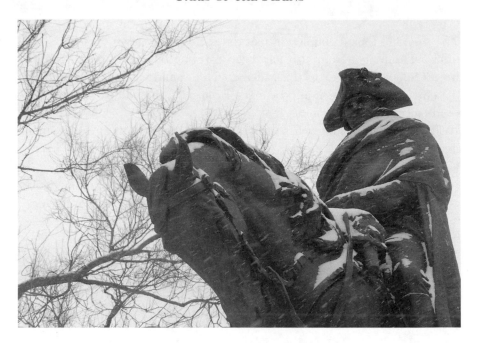

Henry Merwin Shrady's *Valley Forge* at Washington Square Park. *Courtesy of the author.*

Now the forecaster says there's a bigger storm, blasting across the Plains out of the mountains. There will be rain first and then freezing temperatures, heavy snow—much colder; perhaps negative five with a sharp wind. And sure enough, it's snowing plenty, maybe seven inches atop a layer of ice and old snow, and it's blowing and drifting.

If you're a homeowner, make sure you've got coal for the furnace. Maybe some of that Farmer's Red Label, Cherokee Lump or Missouri Nut, which all cost $5.25 to $7.50 a ton.

If you're walking, ladies, snap on your galoshes. Men, your old Army leggings from the world war will keep snow off your trousers.

If you're driving, chop the ice from your driveway so those hinged garage doors will swing open; tighten those chains, or they'll wrap themselves around your axle or flap and knock out your taillights; and good luck with those snowdrifts in the street.

If you're taking public transportation, hope for the best. Streetcars with plows are clearing some tracks; eight hundred men are shoveling others, just in time for passing autos to repack them. Streetcars are backed up all over town, stalled on the ASB Bridge and the Intercity Viaduct, holding up interurban trains from St. Joseph and Lawrence. Buses, rerouted around slippery hills, fare better.

If you're a long-distance traveler, your bus is blocked by snowbound highways, or your train, already delayed by the ten-state storm, now idles in the yards while hundreds of shovelers uncover the switches.

If you're out for fun—no school because it's Saturday—take your sled to any of several hilly streets barricaded for "coasting." Beware of angry truckers; some drive through the barriers. If you're a young woman in the Polar Bear Club, put on your swimsuit and play leapfrog in the snow. Still own one of those old horse-drawn sleighs? Jingle its bells out along the boulevards. Got a toboggan? Tow the neighbors around town behind your Ford.

If you're a Boy Scout, put out crumbs or suet for the birds. "A few crumbs may save a song for next spring," says executive scoutmaster H. Roe Bartle.

If you're homeless, get to the hotel at Sixth and Main. It has a storeroom where you can escape the cold, get a sandwich and stand up all night with four hundred others. The Helping Hand Institute offers shelter and a job shoveling snow downtown. If you're shoveling downtown snow, you're one of five hundred men filling dump trucks and horse-drawn carts.

If you're a nurse or doctor, you're treating a broken wrist from a young motorist's fight with a steering wheel and a snowdrift; a compound arm fracture from a man's fall while chasing his hat, blown off after his car slid into a ditch; or a crushed hand, a lacerated head, a damaged eye—all from collisions of trucks with sleds.

If you're a policeman, you're getting calls from women who would like you to come start a car or shovel snow and bring in the newspaper. You think the weather is keeping crime in check.

You don't believe it if you work in a filling station at Twenty-fifth and Paseo, where a man clomps in and says, "Cold night, isn't it?" And when you agree, he says, "I hate to go out in it again" and flashes a gun and makes off with $87.64.

If you're the Kansas City Public Service Company, take out a newspaper ad to apologize for the streetcar disruptions. Call it "the most severe snowstorm Kansas City has seen for years."

If you're just wandering, notice how snow changes park statues—a pillow of white for the baby in the arms of the *Pioneer Mother* or a look of wintry authenticity for George Washington on horseback at *Valley Forge*.

If you're a dog, find a warm place to sleep inside the west entrance to Union Station, next to the radiators. People coming and going will stop to scratch your ears.

A MAX bus did finally arrive, followed closely by another. I boarded the one tinseled and draped with colored Christmas lights, full of bundled-up passengers and a driver in a leopard-print hat. We headed down Grand in the snowfall, passing city plows, a burly guy with a large umbrella and two Latino men shoveling downtown sidewalks.

Someone sitting behind me sounded resigned to the storm, but he was looking forward to a tropical thirty-degree forecast.

"We'll be all right by Sunday," he said.

Back in 1929, the forecaster is not so sure. He says, "A storm can be hatched up mighty suddenly this time of year."

Chapter 2
1930s

THE PLACE BENEATH

The gravel road is now paved and lined with cars parked alongside the Internal Revenue Service building. But a dense tangle of woods still clings to the western slopes of the Liberty Memorial, and it's not hard to imagine one chill night here in the pit of hard times.

The Union Station red cap told police he remembered a wheelchair. He had pushed it from the entrance to the women's waiting room.

In the chair there was a young woman with her right leg in a plaster cast. On her lap lay a tiny baby in a gray blanket. The baby's left wrist bore a hospital nametag. A middle-age man was with them. It was a Friday afternoon, May 16, 1930.

The red cap said the man asked him to look in on the woman from time to time and then wheel her to a Missouri Pacific train scheduled to depart hours later.

Some time passed. The red cap returned to the waiting room. The young woman was there, but there was no man or baby. She said she wasn't feeling well, and that the man had taken the child to his sister's house outside town. On the next check, the man had returned. He was alone and seemed nervous.

At midnight, said the red cap, the man and woman boarded a train.

The eastbound train steamed out of the sheds into darkness. At the same time, across Pershing Road from the station, up a gravel road and along

Liberty Memorial
from the woods.
Courtesy of the author.

a faint path in some woods below the Liberty Memorial, lay a rusting iron water tank. Inside the tank, wrapped in a gray blanket atop a bed of newspapers, lay a two-week-old, blue-eyed baby girl.

Police found the couple at a house in Jefferson City. She was hiding in a dirt-floor garage out back, lying on a pile of rotting gunnysacks, in pain and barely conscious.

Some of their answers aligned. He was a house painter, and she was an unemployed waitress and factory worker. She had broken her leg. He was her father; she lived with him and her mother. There was a baby, born in a Kansas City hospital. There was talk of adoption, but the baby had disappeared at Union Station.

Beyond that, the stories diverged and details varied. She was married—or not. The baby's father was an Indian from Oklahoma who had worked on the Bagnell Dam project at the Lake of the Ozarks; or the son of a Jefferson City minister; or a married grocery clerk from St. Louis.

She also had a son, four years old, dark-skinned and whose father was the Oklahoma man. Or the unknown father was the reason she never named the boy, simply calling him "Sonny." The broken leg was from a fall down stairs at home, or she was pushed.

They were poor and couldn't afford a baby. Or they had money, which they recently inherited. They went to Kansas City to keep his parents from knowing about the baby. The plan was to have the baby's father take the child from Union Station and do with it as he pleased—or there was no such

plan. The grandfather returned to the waiting room and found the baby gone. The mother, on painkillers, fell asleep in the waiting room. She woke and found the baby gone.

Ultimately the grandfather confessed. He led police across Pershing Road, up the gravel road, along the barely seen path within the tangle of woods below the Liberty Memorial to the empty, rusting iron tank. They couldn't afford a baby, he said. And who would adopt a child with no father or no name?

The mother had agreed to let him leave the child in a random parked car. But the grandfather panicked, thinking someone might see him. He carried the child into the woods and discovered the old tank. A little shelter, he thought.

But when the late-night train left town, temperatures were dropping into the forties. A cold rain fell that weekend on the leaky iron tank in the woods.

A doctor at General Hospital said it would have been impossible for a newborn to survive such conditions for long.

It had been two nights and two mornings. From their nearby home, a man and his twelve-year-old son climbed the overgrown slopes toward Liberty Memorial, gathering firewood. A sound made the boy stop. It sounded like a sort of high-pitched chirping.

"Just a catbird, son," said his father.

They carried their wood home, but the boy returned. He heard the same sound, a little fainter now. In the underbrush, he saw a rusting tank. Inside, there was a tiny baby. He ran home and fetched his mother.

The gray blanket and thin gown were wet from rain. The skin was cold and the little voice was weak, but the child was alive. Her left wrist bore a hospital nametag.

At General Hospital, where her adventure began, the blue-eyed baby girl was revived to ruddy health. People called the switchboard, wanting to adopt her. Well-dressed women came, asking to see her. A man visited, leaving ten dollars. The *Journal-Post* received a letter in crude handwriting:

"I want a baby sister. I want one with blue eyes and black hair. Please do it."

The grandfather got five years for child abandonment, reduced from assault with intent to kill. Charges against the mother were dropped. The prosecutor decided her father had forced her cooperation. Mother and daughter spent two more weeks in the hospital, allowing the broken leg to mend.

For more than eighty years, General Hospital sent patients home through a stone portal etched with a quotation from Shakespeare's Merchant of Venice:

> *The quality of mercy is not strained.*
> *It droppeth as the gentle rain from Heaven*
> *Upon the place beneath. It is twice blessed.*
> *It blesses him that gives and him that takes.*

She'd gotten back her factory job, she said. She wanted to go home and take care of her children.

THE EDGE OF INFINITY

Seventeenth Street descends westward from Summit four blocks before dead-ending at a bluff overlooking the West Bottoms. There, four streets converge: Holly, West Pennway, Beardsley and Seventeenth.

Years ago, before the downtown freeway loop erased it, a fifth—Kersey Coates Drive—also connected here and ran more than a mile north along the bluff through West Terrace Park. The scenic drive and park had replaced several turn-of-the century wooden shacks perched on the hillside.

In the last hours of the winter of 1931, a Phillips 66 filling station sat on the bluff here at the end of Seventeenth, and just north of it an opening in

Remains of Kersey Coates Drive. *Courtesy of the author.*

the curb revealed a rocky pathway that led sixty feet down the steep bluff to a cottage. A throwback to those early wooden shacks, this was the home of the A.E. Mann family.

Probably better than anyone, forty-nine-year-old Arthur Mann, an Arkansas native who worked as a lubricator at an oil company off Southwest Boulevard, knew the pros and cons of this neighborhood aerie.

Writers and artists had compared the terraced park and Kersey Coates Drive to something in the Italian countryside. One visiting author considered the views one of the best among the world's cities. "A long sweep of the Missouri, winding its course between the sandy shores which it so loves to inundate," he wrote. "Beyond, the whole world seems to be spread out—farms and woodland, reaching off into infinity." Then he described the foreground scene: "warehouses and packing houses, and the appalling web of railroad tracks, crammed with freight cars, which form the Kansas City industrial district."

At times, this was a place for criminal activity. Two years earlier, a cashier had been robbed of payroll money on Kersey Coates Drive. The next year, a local bootlegger was shot dead in his car on the same road.

And there had been near-disasters with vehicles. The man running the filling station had seen more than one driver misread the curb opening above the Mann cottage as a continuation of the street, stopping with front wheels hanging over the precipice.

So possibly Arthur Mann and family—forty-nine-year-old wife, eleven-year-old daughter, seventy-year-old mother-in-law—were not unprepared for the early morning of March 21, 1931.

It had been raining in Kansas City, and temperatures after midnight hovered just above freezing. At 1:15 a.m., the Manns were shaken from sleep by a loud crash.

Outside, Arthur Mann found a 1930 Ford coupe leaning on two wheels against the splintered remains of his porch. Two young men lay bleeding on the rocky ground nearby. A third was up, trying to move one of the others. Seeing Mann, he asked to go inside and wash his hands.

"Please don't call the police," he said. "Don't tell our folks; they'll be scared to death. Just call an ambulance, quick."

Police learned the three were students at the University of Kansas, all from small Kansas towns. Out for a drive, they'd stopped for barbecue and were

on their way back to Lawrence. Instead of turning into Beardsley from Seventeenth Street and traveling north to the Intercity viaduct, they drove straight ahead at thirty-five miles an hour, through the opening in the curb, bouncing then rolling over and over, down the cliff into the Mann house.

Two hours later at General Hospital, one of the three—an honor-roll student and fraternity president—died of his injuries.

Back at the Mann house, police searched the car and grounds for evidence of alcohol, finding only a blanket, a small radio, some tools, a deck of cards and a raincoat. And up on the roof of the house, a man's hat. The label was from a Lawrence store. The headband was bloodstained.

Today, the cliff is a jungle of weeds and trees. The Phillips station and the Mann house are long gone, replaced by a tattered billboard and a sign warning trespassers. Nearby, the only surviving witnesses to a fatal morning in 1931—a stone wall, rusting handrail and grassy roadbed, all remnants of Kersey Coates Drive—still gaze toward the river and the world spread out, reaching off into infinity.

In the Valley of the Missouri

The rains come and the Missouri River rises, tickling the trunks of slender green trees along the shorelines between the downtown bridges. Its current runs strong and silent, and the slate-colored waters are often full of logs and branches and the flimsy, man-made debris that any good spring storm will launch on a bon voyage toward the Gulf of Mexico.

The pedestrian walkway known as the Town of Kansas Bridge, above the remnants of the old Municipal Wharf at the foot of Main Street, is a good place to watch.

It looks almost as if the river has remembered something of its wild youth, when it did as it pleased. Serpentine and studded with sand bars, it was slow and small in wintertime. Come spring, it would gorge on rains and spread itself over the land and then recede, sometimes into new channels, reinventing itself.

Eventually, progress demanded that wildness be tamed.

I'm down by the river, listening to a soundtrack provided by young frogs, angry blue jays and a freight train on the ASB Bridge, and I'm contemplating a partial list of those who have passed this way before me: Indians of various

Remnants of the working waterfront on the Missouri River. *Courtesy of the author.*

tribes, African slaves and Frenchmen in wooden canoes; a dead man, ten days afloat from St. Joseph; kayakers, steamboat captains and ferry operators; Creoles onshore, hauling keelboats with long ropes; gold rushers, bargemen and thugs disposing of unwanted weapons; eight Boy Scouts bound for St. Louis in yellow Navy surplus rafts; gypsies on shanty houseboats, catfish noodlers and Lewis and Clark; and army engineers.

I'm wondering if there might be two types of people historically associated with this river—those who fight the current and those who don't. The former group would be ably represented by the army engineers.

The riverfront is slowly returning to a green, seminatural state of grasses, brush and cottonwoods, and people are enjoying amenities like the pedestrian bridge, a park and a landscaped shoreline trail. It's a far cry from the industrial scene of years ago. But despite its historical importance, the Missouri sometimes seems like an afterthought in Kansas City.

There was a time when it could draw a crowd. As in 1932, to celebrate the opening of a new six-foot navigation channel from Kansas City to the Mississippi River; it was a channel that ensured yearlong passage with no

snags or sandbars to prevent a barge from carrying the fruits of heartland labor to the world. It was a celebration of engineering, the use of steel, stone and woven willow branches to force the river to scour its own new channel.

And fourteen years later, when people turned out for a ceremonial groundbreaking for a new flood wall from the Kansas line to the ASB Bridge. It was the tiny beginning of the massive, $1.2 billion federal Pick-Sloan project, which extended the navigation channel to Iowa, but it also provided flood control, electricity production, irrigation and recreation opportunities via a series of upstream dams and reservoirs.

"It will stop the ravages of floodwaters and provide billions of gallons of water for irrigation and untold amounts of cheap electric power for industry," proclaimed General Lewis A. Pick of the army engineers, spading a chunk of West Bottoms clay at the foot of Mulberry Street. "Think what it will mean to the businessmen of the Middle West."

The general answered himself by proclaiming "a new and greater era, an era of security, progress and better living in the valley of the Missouri."

It's possible to sit on the banks of the Missouri and not think about some unintended consequences of the general's new and greater era, such as the anger of Native Americans, upset over tribal acreage lost to the chain of reservoirs; the upriver–downriver dispute over water for recreation interests versus shipping interests; or the concerns of environmentalists about loss of habitat and wildlife dependent on the river's natural flood cycles. It's possible—especially in a Kansas City spring, when the river looks youthful and spirited.

So now I'm sitting here on some old concrete steps that lead down to the water's edge, daydreaming about going with the flow, living as a gypsy on my shanty houseboat, watching fields and towns slide past and drifting with the brown current toward the sea.

THE NEIGHBORS' WORKDAY

The fried-egg sandwich in the diner off the Union Station lobby was food for thought. One morning before the place went out of business, I was sitting at the counter, enjoying that breakfast and thinking about a story my grandmother often told.

It was a story from the early 1930s about some neighbors she once had. My mother's family then lived in an Armour Hills bungalow on Edgevale

The east entrance
at Union Station.
Courtesy of the author.

Road. These neighbors—a man, woman and a young girl—had recently moved into a rented house across the street.

The house attracted mysterious activity: cars with out-of-state tags and people coming and going at all hours, often carrying odd luggage. The renters kept to themselves, and no one was sure about their line of work. My grandmother would not let my mother and aunt play with the little girl, so the three children would stand in their respective yards, staring at each other across the street.

The upshot of her story was that one morning, some men walked out of the house with their odd luggage, got in a car and presumably went to work. But they didn't come home that night or ever again.

I was thinking that events elsewhere that morning must have inspired other stories, told and retold countless times.

It was the morning of June 17, 1933—a Saturday.

My own story, had I been in Union Station that morning, might begin early at the Harvey House counter with a plate of eggs and a newspaper, reading about a couple of outlaws. Pretty Boy Floyd and Adam Richetti were running from the law somewhere just south of Kansas City after having kidnapped a rural sheriff. The U.S. attorney general was planning a war on crime. "It is warfare, pure and simple," he was quoted as saying. "Gangsters must go." And federal officers had captured an escaped convict named Frank Nash in Arkansas. They were returning him to Leavenworth on a train. The weather was going to be hot, near ninety. But it was still comfortable, maybe seventy, just after 7:00 a.m.

He was a retired country editor. His story would begin when he arrived on the 7:15 from Moberly. He climbed the stairs from the train shed to the lobby and headed toward the taxi stand outside the station's east entrance. What if he hadn't stopped first to buy that cigar at the cigar stand?

He was a clerk in the station bookstore. He noticed a group of several men walking in close formation across the marble floor of the lobby, toward the east entrance. One of the men was wearing handcuffs. Other people in the lobby were following the men out the door. He followed, too.

He was an attendant at the taxi baggage stand. He saw three men in the group carrying rifles or shotguns. He remarked about how well the prisoner was guarded.

He was the taxi starter, hailing cabs from the wide front sidewalk. He saw the group pass him and cross the lot to a parked car. He saw the prisoner get in the car first.

He was a station red cap. He had just helped put a passenger into a waiting cab. He turned around and saw a man with a short gun.

He was a truck driver from St. Louis, unloading tires down the street at the Goodrich Company. He heard what sounded like a firecracker. "Starting their Fourth of July celebrations early," he said to a co-worker.

He was a cab driver, waiting in line outside the station for a fare. He heard one shot, turned and saw a man firing a machine gun at a parked car, swinging it from one side to the other.

She was a mother meeting her son's train, standing near the lobby doors to the train sheds. She heard shooting, saw flashes of red near the entrance and people running toward her.

She was the Harvey House cashier. She heard glass shattering at the front of the station, saw shards spray across the lobby and people running. Must be a holdup, she thought. She grabbed money from the register, stashed it under the counter and phoned in a riot call.

She worked the Travelers Aid desk in the lobby. She saw six Catholic nuns among dozens of pedestrians on the sidewalk. She ran out and called to them. Four ran; two stood frozen. Someone grabbed their arms and pulled them inside.

He was a cab driver. He saw four gunmen escape in a dark, late-model Chevrolet sedan, heading west on Pershing at high speed.

He was a streetcar operator. At 7:23 a.m., while unloading passengers at Thirty-first and Main, he saw a dark sedan, maybe a Chevrolet, make a wide, screeching turn from Thirty-first into Main and then race south.

He was a railroad man, up from the sheds, having heard shooting. Looking

outside, he saw someone pointing at a car and ran to take a look. There were three bleeding men on the ground and three more in the car; one of them was handcuffed. A shell casing lay on the ground. He picked it up and put it in his pocket.

She and her mother had driven down early that morning to meet a train and parked in the first row. She wanted to wait in the car. Her mother said no; she needed her because there were two arrival doors to watch. When they returned, they found a crowd near their car, bodies and blood on the ground and in the car parked beside theirs. Their car was laced with bullet holes.

Whenever I heard my grandmother's story, I had two reactions. One, that it was cautionary: If you're engaged in mysterious all-hours activities involving odd luggage, one day you might not come home from work. And two, that she had a good imagination.

But it turns out she was partly right. Although controversy exists about the identity of some of the gunmen—Was it Floyd and Richetti? Local thugs?— when prisoner Frank Nash and four law enforcement officers died in the Union Station Massacre, one name is certain: Verne Miller.

After the killings, police learned that Miller, along with his girlfriend and her daughter, had lived under an assumed name in the rented bungalow across Edgevale Road from my grandparents. And there was evidence that other notorious figures of the day had spent time there.

But my grandmother was wrong about one thing. Miller and his cohorts apparently did return home for at least one more night in the rented bungalow, even as she sat across the street in her living room reading a story in an evening newspaper about their day at work.

No. 14,327

It was a customer's receipt from Woolf Brothers clothing store, issued to a doctor who lived on Wyoming Street, for the amount of seven dollars. Dated January 10, 1934, it got me wondering what else happened in town that day.

A man died at home on Sixty-eighth Street; a woman died at home on Jefferson Street; a man died outside a filling station with a burglar's jimmy and a spark plug in his pocket and two police bullets in his head. A woman put on a blue dress and shot herself twice with her husband's .35-caliber pistol, killing their unborn son.

The Woolf Brothers receipt. *Courtesy of the author..*

It was a Wednesday, cloudy and cold in Kansas City, and there was snow on the ground. Someone bought peppermint candy ice cream, which was the special at the Linwood Ice Cream Company. Someone ordered a ton of semianthracite, the special at Neil Barron Coal. Someone bought a tin of Shinola at Katz Drug. Someone ordered two loaves of salt-rising bread from Wolferman's grocery. Someone dreamed of wintering in Havana.

Twenty-five hundred people received licenses to drive. Ten couples got licenses to marry. One woman sued for divorce after forty-six years, while another couple celebrated sixty years together. Someone bought tickets to a polio benefit at the Pla-Mor Ballroom, celebrating President Roosevelt's fifty-second birthday. Someone boarded an airplane at Municipal Airport, leaving for New York. Someone booked a sleeper on a westbound train.

She paid thirty-five cents for lunch and a tea-leaf reading at the Egyptian Tea Room. He hoped someone would find his dog, a wire-haired terrier named Punch—white with a brown face. She answered an ad in the newspaper: "Girl—white, 20 to 30 years old; housework and cooking, care of 2 children; stay nights; city references; $5 a week."

He received his badge at a meeting of Boy Scout Troop 24. They robbed a bank of $2,500 and escaped in a 1933 Dodge sedan with Kansas tags, 19-6110. They played cards and danced with their wives at a party thrown by Meat Cutters Association Local 576. He sank the last-minute winning basket in the church league at Van Brunt Presbyterian.

Someone paid a quarter to see *Duck Soup* and a Betty Boop cartoon at the Plaza Theater. Someone paid a quarter to hear the George E. Lee and Bennie

Moten Combination Orchestra at the Harlem Nite Club. Someone paid fifty cents to take Brazilian Carioca lessons from Professor Wolfe. Someone stayed home to listen to *Amos 'n' Andy* on the radio. Someone lingered over a four-letter word for "alcohol radical" in a crossword puzzle.

A doctor spent seven dollars at a clothing store near his downtown office. He was a thirty-nine-year-old chest physician with a wife and no children. The day was no. 14,327 in his earthly allotment of days.

If on his final day—no. 31,783—the doctor could have been shown the receipt, perhaps he might have recalled something specific: a favorite tie, shirt or pair of shoes; a night out with his wife; a visit from a patient; maybe his single best day, or his worst. He might have stared at the date and wondered where all the days had gone.

THE MUSIC OF LOVE

Like me, the guy was out enjoying the warm February weather. We were on a block of Campbell Street that is lined with well-worn but still-handsome houses of a familiar type in Kansas City: multiple stories, front porches and postage-stamp yards. It was an historic neighborhood, the street signs say, and it's not hard to imagine grander days when nearby Armour Boulevard was a more fashionable address.

We stopped to chat. It was a good old neighborhood, we agreed. He just moved in recently, he said, and lived in that house there; he was fixing it up. I was just out for a stroll, I said, killing time before a haircut appointment. That was partly true. I didn't say I was here because of what I knew about his property; that a lifetime ago—Valentine's Day 1934—two lovers died, violently and mysteriously, on his patch of sidewalk.

As do all mysterious crimes, this one had a set of givens.

There were two bodies—a man and a woman—sprawled across the sidewalk. They were discovered at 11:15 p.m. by two neighborhood teenagers who heard two gunshots. The woman had been shot once in the right temple, and the man was shot once in the mouth. The man had ninety-five cents in his pocket and a .38-caliber revolver in his right hand.

Beyond that, police learned she was a nineteen-year-old stenographer for a Kansas City mail-order company. He was a twenty-three-year-old student at William Jewell College in Liberty. They had been on a date to the movies. He had picked her up at her home, a door away from

The lovers and their Campbell Street sidewalk. *Courtesy of the author.*

the crime scene, at about 8:00 p.m. that evening. She had been renting a room there for about three weeks. They had left the house in good spirits. They were planning to marry after his graduation in June. He had a job prospect in Chicago.

In time came a secondary layer of information. He grew up in a small southwest Missouri town as the tenth of eleven children. Friends said he was always short of money, but they knew him as carefree and pleasant. Others called him "excitable." He held a job cleaning a campus building, and he liked to whistle as he worked. Friends called him the "whistling janitor." He was a divinity student.

She and four sisters grew up in an orphanage in Liberty. She graduated second in her high school class. She sometimes suffered brief spells or attacks when she became confused and irrational for several minutes; she then recovered with no apparent effects. She was under treatment. Friends said she always appeared happy and often sang or hummed while she worked.

And, finally, there was a third layer. It was a letter from him that was discovered in her room:

> *"Darling, you are sure of me, aren't you? You know I love you more than life itself. If I weren't sure of you I'd be miserable most of the time. When we get out of this mess, we're going to keep our noses clean. Life is too short. We don't want anything to come between us. I'll do my part and am sure you will do yours."*

The landlady remembered her saying she would not marry him, that "it would be silly for us to marry when he has no job nor any prospects of one." A friend remembered him saying it "was a lovely thing for lovers to die together." The autopsies revealed no disease or pregnancy. Police called it a murder–suicide, with no clear motive.

So we're left to speculate and to connect whatever dots we can find. Did she intend to marry him? Was there really a job prospect? What was the nature of the "mess?" Did she suffer one of her spells during their date? Did he talk of the beauty of dying together? And what movie did they see? Was it the comedy, musical, western, hospital drama or jungle thriller playing in one of many neighborhood theaters? Did he take her downtown, treating his valentine to something more pointed and grand? Perhaps it was the hard-times, love-and-loss story at the Mainstreet. Or the storybook love-and-loss story at the Midland.

It's the music—his whistling and her humming—that lingers in my mind.

In the movie I would make, the final scene is serene and almost beatific. On the drive home, he's been whistling a haunting tune he can't get out of his head. She says something like, "Oh, I love that song. What's it called?" and begins to hum softly along. He pulls the car to the curb, gets out and opens her door. They walk toward her house. The day has been unseasonably warm and the night cool but not uncomfortable. He slips an arm around her shoulder, his hand into his coat pocket and feels the smooth weight of the gun. "Wait a minute," he says to her. "Close your eyes." And the tune loops again and again.

Hard Times at Gateway Loan

Standing on this corner, where the new downtown meets the old, I'm trying to picture an earlier 1300 block of Main, before its Power & Light District makeover.

Except for a brave tuxedo-rental store, it wasn't much. There was a cocktail lounge, a place that sold newspapers and porn magazines, a haunted house, a massage parlor and several asphalt car pastures. One of those parking lots was right here in the shadows of the Mainstreet Theater and the Hotel President. It's now a new storefront that stands vacant in these hard times.

Now imagine a different storefront during even harder times; and two policemen with riot guns, answering a burglar alarm on a cold Friday morning the week before Thanksgiving 1935.

Each man received a coat that fit and was out the door. *Courtesy of http://criticalpast.com.*

It was the morning after opening night of the Kansas City Philharmonic's third season, its last at the old Convention Hall at Thirteenth and Central.

The concert ended at 10:00 p.m., and the city's black-tie finest—in top hats, furs and imported topcoats—milled about in the chilly night air, admiring the lights on the new Municipal Auditorium that was nearing completion across the street. The arena's three marquees were switched on just for the concertgoers.

No doubt the brilliant lights and the music of Sibelius, Strauss and Brahms helped soothe any disdain for President Roosevelt's extravagant spending: $4 billion to put millions of unemployed to work. Some of that money was in this new arena.

As the crowd drifted home, a lone figure just beyond the glow of lights made his way toward the corner of Fourteenth and Main, then another and then a third. Thinly dressed, they huddled outside a locked storefront. At 11:00 p.m., the temperature was thirty-four degrees.

At 3:00 a.m. it was thirty-two degrees. Fifty men waited outside the store. By 8:00 a.m., the line stretched up Main to Thirteenth, west a block to Baltimore and back south toward the Hotel President. It was twenty-six degrees. Those in line wore light jackets or overalls and several shirts. They

were old men and young boys. Some carried a classified ad torn from a newspaper: "OVERCOATS—700 free to men unemployed. Apply 8 a.m. Friday. Gateway Loan and Sporting Goods. 1330 Main."

What had started years earlier as a way for proprietor Louis Cumonow to get rid of fifty extra second-hand coats had become an annual event. He bought coats from a man in Philadelphia, who got them from military recruits who had no further use for them. Then he published an ad, and he gave them away—first come, first served.

That morning, because of the cold, he and his clerks fitted the hundreds of men inside the store, four at a time, and quickly, under a minute each. Each man received a coat that fit and was out the door, and another came right behind him. Then the cops arrived with their riot guns and demanded to know what was going on.

No burglary, said Louis Cumonow. He was just giving away coats. Someone must have dropped one on the alarm button.

The seven hundred coats were gone by 10:00 a.m. But customers remained, and Louis Cumonow kept giving away coats, no questions asked.

"I picked out about thirty old men, cripples and little boys and gave them coats out of my regular stock," he said later.

"Of course some don't deserve them. But most do. Today three men came back with their new coats and wanted to do some work. That pleases me enough."

Elsewhere in town that day, men were buying overcoats at Jack Henry, Rothschild's and Woolf Brothers. "Imported from England—Soft, luxurious, wrinkle proof—Alpaca and Angora yarns—Generous lines that are slightly fitted, giving that smart English Drape—$28.50 to $65."

And the next morning, Louis Cumonow ran a new classified ad: "TOPCOATS, overcoats, jackets; left in pawn; $3 up. Gateway Loan, 1330 Main."

THE PRESIDENT COMES TO TOWN

I'm standing in the southwest corner of the upper tier of the new Municipal Auditorium. With me are twenty thousand other folks, outnumbering the seats, with many standing in the aisles. We're watching and listening to the president of the United States, Franklin Delano Roosevelt.

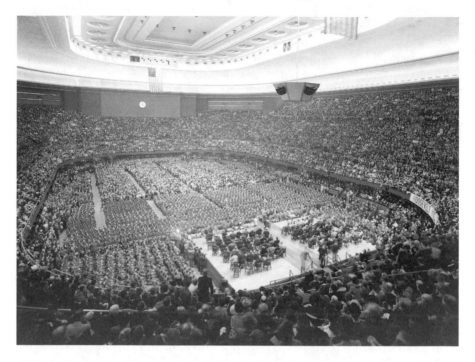

"America has lost a good many things during the depression," President Franklin Delano Roosevelt said during a visit to Kansas City on October 13, 1936. *Courtesy of Missouri Valley Special Collections, Kansas City Public Library, Kansas City, Missouri.*

FDR is standing behind a rostrum built especially for this day: aluminum with reading lights, electrical hookups for the house speakers and the radio broadcasts, handrails and side panels that conceal his legs, which have been withered by polio.

Officially, this is the auditorium's dedication, though it's been open since last December. But it's an election year, and we're a stop on the president's ten-day, twelve-state campaign tour by train. He's just arrived from Wichita, in the home state of his opponent, Alf Landon, where he cited a "gospel of fear" spread by Republicans about his administration.

Here, a large contingent of ROTC boys is sitting down front, as are members of the Young Democratic Clubs of several states; the president has mentioned the Civilian Conservation Corps, a work program for youth his administration founded. He said:

> *America has lost a good many things during the depression. We have lost,*
> *for example, that false sense of values that puts financial success above*

every other kind of achievement. We have lost something of that feeling that ours is an "every-man-for-himself" kind of society, in which the law of the jungle is law enough...But many things we have saved—things worth saving. We have saved our morale. We have preserved our belief in American institutions. We have saved above all our faith in the future—a faith under which America has only begun to march.

Afterward, the ovation will be loud and long, and FDR will walk with assistance from the stage down a wooden ramp to a waiting open car. He'll leave the auditorium for the warm Tuesday afternoon sunlight by way of downtown streets lined with thousands more people waving flags and handkerchiefs and holding balloons all the way to Union Station.

Later today, in Detroit, Governor Landon will warn his audience that Roosevelt is building a strong central government and possibly a dictatorship. Just before the election, *Literary Digest* will publish its poll assuring a Landon landslide. And then, in November, the president will win sixty percent of the popular vote, carrying forty-six of forty-eight states, including Kansas.

Tonight in Kansas City, after the president's special train eases out of town toward St. Louis, after the streets are cleared of snarled traffic, a taxi driver will pull over at Twelfth and Baltimore.

"I don't know what the New Deal has done for business," he'll say. "But all Roosevelt has to do to get me out of a depression is to come to town."

BEFORE THE WIND SHIFTED

Gazing down the long sweep of Gillham Park—the grassy finger of lowland playground tucked between the Hyde Park and Rockhill neighborhoods alongside Gillham Road, south of Thirty-ninth—I'm not seeing an ideal spot for a city-sanctioned, toxic bonfire.

I don't know whether such an event is something George Kessler imagined when he designed the parks-and-boulevard system a century ago. I'm pretty sure of what the neighbors would say now.

But late one January in the hard times of 1937, it seemed a perfectly logical idea. It was just one of several heard around town that week.

It was Sunday of the week after President Roosevelt's second inauguration. News was dominated by the flooding Ohio River and a sit-down strike at General Motors. Sunday was opening day of the Used Car Show, during

Detail of the parks department's maintenance building at Gillham Park. *Courtesy of the author.*

which Kansas City auto dealers would be trying to clear lots to make way for the new models. That evening, just up the hill from Gillham Park in a house on Holmes Street, a visitor was speaking to a small group of friends. A Jewish man, editor of the *Palestine Daily Mail* in Jerusalem, said "the Jews have re-inherited Palestine; we have not conquered it," attributing recent trouble there to German-made weaponry provided to Arabs by the Nazis.

"A permanent solution of the recurrent Jewish–Arab riotings will be reached within about five years," he said. "By that time the two groups will have reached an approximate parity in population."

Two days later, the Advertising Club welcomed French visitors to a luncheon at the Hotel Baltimore downtown; they were promoters of a Paris exposition to open in May. One, an economic writer for *Le Petit Parisien*, dismissed concerns about events in Europe. Rearmament, he said, presaged peace, not war.

"As a Frenchman," he said, "I believe that as long as France and England stand together there will be no European war."

The next day, four thousand people filed into Municipal Auditorium for a program sponsored by a group called the World Peace Council of Kansas City. Two years earlier, Congress had passed the Neutrality Act, which prohibited the sale of arms to any country at war with another. In a Gallup Poll, seventy-five percent of Americans had said any declaration of war should be subject to a vote of the people.

Speakers that day included two Englishmen—a young college student and an old preacher.

"We must be firm and resolute and not be deceived by idealistic war slogans," said the student. "We realize the tremendous 'ideals' people die for are mostly tremendous farces."

"If you can keep peace in your hemisphere it will light a ray of hope in the Old World," said the preacher. "Don't waste your genius and resources to devise ways to destroy, but use them to drive fear and poverty from the world."

While the auditorium crowd listened to pleas for peace, workmen with tow trucks were piling junked cars just south of the old maintenance building in Gillham Park, About a hundred such heaps, deemed unsafe for city streets, had been donated by dealers all over town for a publicity stunt to promote the Used Car Show and to help sell old Fords, Chevrolets, Studebakers, Hudsons, Packards and Terraplanes.

Temperatures had been in the forties all day, but patches of snow clung to hillsides flanking the park. Spectators—perhaps thousands—formed a ring from Locust to Kenwood and Thirty-ninth to Forty-third Streets, watching a tanker truck spritz four hundred gallons of gasoline and kerosene on the stack of cars. Firefighters, police and a hundred Boy Scouts stood by.

At 8:00 p.m., some men representing the fire department, the Safety Council and the car dealers lowered torches to four fifty-foot "fuses" of gasoline-soaked straw.

The next morning, a *Times* reporter described "a dozen pillars of fire" shooting thirty feet skyward, and the "brightly lighted" surrounding hillsides. Spectators cheering as tires "burst loudly, some burst shrilly and one exploded with a bang." The burning carcasses were "red in the heavy smoke and flames." A southern breeze "carried the fumes of burning rubber into the crowd north of the pyre, and hundreds of watchers fled."

"FIRE MAKES ROADS SAFER," the headline declared. The bonfire was reported to be part of a "campaign to remove dangerous antiquated machines from the streets." The article closed with promoters announcing intentions to "make this an annual affair. It's a lot of fun and it serves a good purpose."

Here in the twenty-first century, I see that this idea—and its "good purpose"— existed only in the *Kansas City Star* and its partner, the *Times*, where Used Car Show advertising appeared, and not in the competing *Journal-Post*.

I'm thinking the value of any idea depends on where you're standing and which way the wind is blowing.

Directed by DeMille

I'm standing at a window on the original mezzanine of the Hotel Muehlebach, looking at the old hotel's wavy reflection in the modern glass tower across Baltimore Street. A dreamlike image, it creates the appropriate state of mind for imagining a legendary Hollywood director at work here.

Cecil B. DeMille stepped off the train from Chicago at 11 o'clock the morning of January 21, 1938. He had written a tight script for a single day here: lunching with local dignitaries, including the mayor, in the Muehlebach's Tea Room; speaking at a preview of his latest movie, *The Buccaneer*, at the Newman Theater; and giving his daughter in marriage in the Muehlebach's penthouse. Kansas City, centrally located, provided the ideal set for killing several birds with a single stone.

The storyline had DeMille meeting his wife, daughter Cecilia, and her intended, Joseph Harper, all who had arrived earlier by train from Los Angeles. With him from Chicago he had brought two actors from *The Buccaneer*, Margot Grahame and Akim Tamiroff, who would appear at the preview and then play supporting roles as bridesmaid and best man.

But as the DeMille entourage hurried across the lobby of Union Station, a young girl from Texas approached and reached for the director's hand. She was Minnie Jean Lamb, age twelve, and she recited a line she must have rehearsed many times over the five hundred miles from Texarkana.

"I want to go to Hollywood," she said.

The Hotel Muehlebach, reflected across Baltimore Street. *Courtesy of the author.*

Later at the hotel, the DeMille family sat on a sofa and chatted with reporters.

"The wedding tonight will be simple," said the director. "Yes, 11 o'clock. That is, if I get back here from the theater by that time."

Photographers asked for a few pictures.

"Here, now, we shouldn't sit that way," DeMille said. "I should be over here and Cecilia next and you move over there by Joe. Now get your mind off that camera. How's that light coming from the left window?"

That night, a full house at the Newman applauded as the house lights came up and the director strode across the stage and spoke briefly about the heroism of Jean Lafitte, the pirate protagonist of *The Buccaneer*, and then introduced the two actors, who gave brief thanks and accepted flowers. Then they went back to the Muehlebach.

It was well past 11:00 p.m. before the photographers had finished with the wedding party and the ceremony could begin. The director marched confidently past the snapdragons, roses and fifteen guests to deliver the bride to her groom. The couple recited the vows, each for a second time in their lives. As DeMille had announced to the Newman audience as he was leaving for the hotel, this was his "greatest production."

Across town in the darkness of her aunt's bungalow on Jefferson Street, a twelve-year-old girl from Texas must have been replaying her scene, now on the cutting room floor.

"I want to go to Hollywood," she had said.

"So does almost everyone else in the country. You're a little young for my pictures."

"But look at Shirley Temple. She's young and she's working."

"Yes, but she's not working for me. You go back to school."

And so ended the dialogue, allowing Minnie Jean Lamb to return to Texarkana and tell a story of how Cecil B. DeMille directed her life story.

At First, the Last Time

Hallowed ground in Kansas City sports history is not named Kauffman or Arrowhead, but Monarch Manor—a development of new Craftsman-style houses where the curve of East Twenty-first Terrace mimics the sweep of a grandstand and the sidewalk echoes a right-field foul line.

The curve of the street mimics the sweep of a grandstand. *Courtesy of the author.*

As true Kansas City sports fans know, there used to be a ballpark here. It had a succession of names—Muehlebach Field, Ruppert Stadium, Blues Stadium and Municipal Stadium—and it was home turf for more than fifty seasons of Blues, Monarchs, Athletics, Royals and Chiefs.

By my estimates, first base was right about here, between Garfield and Euclid Streets, several feet under the infill soil of what is now Lot 35, Monarch Manor. John "Buck" O'Neil worked this ground for the first time as a Monarch in the second game of the 1938 season-opening double-header, but I'm thinking of another obscure milestone that came a year later: Lou Gehrig's final game.

It was baseball's centennial season, and it was the first time the New York Yankees had played in Kansas City.

The Yanks arrived early Monday morning, June 12, 1939, rolling into Union Station aboard three Pullman sleepers. They had just come from beating up the lowly St. Louis Browns to play an exhibition against the Blues, their American Association minor-league affiliate.

New York had won the 1938 World Series and had a current record of thirty-seven wins and nine losses. The Blues were Little World Series champs and would win 107 games in 1939. (Years later, they would be named one of the all-time great minor-league teams.)

The Blues were led by a young infield of future major leaguers: Johnny Sturm at first, Jerry Priddy at second, Phil Rizzuto at short and Billy Hitchcock at third. Their slugging center fielder, Vince DiMaggio, would be playing against his little brother, Joe, who was the Yankees's slugging center fielder.

Gehrig, who was about to turn thirty-six, would be in uniform but not expected to play. Six weeks earlier, the longtime Yankee captain had taken himself out of a game in Detroit, ending a streak of consecutive games played after fourteen years and 2,130 games.

"There's something wrong with me," he had told a friend. "It started over the winter. I lost weight and I felt like I was getting weak. This spring it just seems like I'm weaker and weaker and weaker…I don't know what it is."

Today, most fans believe the Detroit game was his last. But there was one more.

Although the Yankees would be in town just for the day, they checked into the Hotel President to shower, eat and rest before heading to the ballpark for 1:00 p.m. batting practice.

Besides Gehrig and DiMaggio, these were the Yankees of Crosetti, Gordon, Henrich, Dickey, Keller and Gomez. They were heroes, previously seen by Kansas City fans only in newspaper photos or grainy newsreels at the movies. People filled streets in front of the President and clogged traffic.

All twelve thousand box and reserved seats at Ruppert Stadium had been sold out for days. Gates opened at 11:00 a.m.—an hour ahead of schedule— for walk-ups to buy five thousand general admission seats. By a little past noon, only standing-room tickets remained.

They overflowed the seats and spilled onto grassy slopes behind third base and right field. They stood on ramps or six deep behind the last row of the grandstand. They climbed the pitched roofs of concession stands. They perched atop the outfield wall. All 23,864 of them. The temperature was in the seventies, and it was muggy when the first pitch was thrown at 2:30.

"This is quite a crowd," said a New York reporter in the press box. "We played to eight thousand in Sunday's doubleheader in St. Louis."

The Yankees scored a run in the first and then took the field. One of them walked slowly across the diamond and took his position at first base. It was

not Babe Dahlgren, who had replaced Gehrig in the regular starting lineup, but Gehrig himself.

After the game, the Yankees returned to the hotel. They had a game Wednesday in New York, and they'd be riding their Pullmans behind an eastbound night train—all of them except one.

Lou Gehrig would be spending the night at the Hotel President. There was an early flight to Minnesota the next morning. He had an appointment for a checkup at the Mayo Clinic.

"I guess everybody wonders why I'm going, but I can't help believing there's something wrong with me," he told a Kansas City reporter. "I'd like to play some more and I want somebody to tell me what's wrong. Usually a fellow slows up gradually."

Gehrig's biographers have suggested he played that day because the huge crowd wanted to see him. Or perhaps he wanted to give it one more try before his Mayo examination.

The box score shows the Yankees beat the Blues 4–1, and Gehrig played three innings. He grounded to second in his only at-bat and recorded four putouts at first. The only suggestion of anything wrong was a reporter's description of a Blues player pushing "a hit past the slow-moving Gehrig."

Years later, others who played that day had darker memories. Blues catcher Clyde McCullough recalled a line drive that knocked Gehrig on his back. Two of Gehrig's fielding chances were said to have been errors that weren't scored as such. Phil Rizzuto, who had idolized Gehrig as a youth, remembered a once-powerful body that seemed shrunken and hobbled.

"Oh, it was a sad day," Rizzuto said.

The Mayo Clinic diagnosis was amyotrophic lateral sclerosis.

In two weeks, Gehrig was back in New York, giving his retirement speech in front of a clutch of microphones on the Yankee Stadium infield, calling himself "the luckiest man on the face of the earth." In two years, he was dead.

Surely those final two years were overcrowded with bittersweet memories: teammates and opponents; home runs and strikeouts; pennants and disappointments; and the beginning, and the end, of the streak.

And maybe even that last sliver of time at first base, the smooth leather of an old mitt, the green Kansas City grass, the start of the windup, the white ball, waiting.

Chapter 3
1940s

WHAT THE FOUNTAIN SAW

Enrico Caruso slept here; so did Amelia Earhart, Teddy Roosevelt and Ethel Barrymore. They stayed right here on Baltimore between Eleventh and Twelfth. I'm wondering whether that's what the men in overalls were thinking.

They should have begun on a Friday but they said it would be unlucky. There were thirteen of them. So they arrived on a Tuesday with their wrenches, hammers and crowbars. Dust coated the marble and mahogany, the brass capitals, the enameled iron, gold leaf, glass mosaic and all else in the drafty building that once boasted of "everything that art, science, and taste combined could furnish to render it as near perfect as possible."

And the wrecking began on February 20, 1940.

It's been nearly a lifetime since anyone last saw the Hotel Baltimore in Kansas City. Once likened to such palaces as Chicago's Palmer House and New York's Waldorf, the Baltimore was known in its heyday as "the center of the city's bon ton social life." It opened at the end of the nineteenth century and closed its doors at the height of the "streamlined age." It had a lifespan of less than forty years. At the end, a newspaper writer decided it was "a nightmare of perverse and useless extravagance."

What were they thinking, those men in overalls, as they went about their work? Was it just a job, a simple matter of putting wrench to radiator and taking down another building, piece by piece? Chances are many of them couldn't remember a time when there was no Hotel Baltimore.

The Carrara marble fountain from the Hotel Baltimore. *Courtesy of the author.*

The auction was over. The china, silver and glassware, the kitchen equipment, the light fixtures, the plush furniture and the beds, linens and dressers were now scattered around town and beyond in private homes, resale stores and who knows where. Essentially, what remained of the Baltimore—what the building wreckers saw—was the empty nineteenth-century dream of architect Louis Curtiss.

They saw the rich green marble of the lobby and the curving balustrade of the mezzanine balcony up the main staircase. If they ventured downstairs, they saw the dark Heidelberg Bar with its German murals, its half-moon shaped mahogany bar and its entrance to the white-tile tunnel that once ran under Eleventh Street to the Willis Wood Theater.

Upstairs, they saw the main dining room with its soft greens and deep yellows; its mosaic tile floor under a dome fifty feet high; the woody banquet hall with its wrap-around mural of medieval knights and ladies; and the vast Pompeian Room with its Carrara marble fountain like a huge loving cup. And everywhere there were columns, Roman Ionic and Grecian Doric, supporting ornate plastered ceilings.

What were they thinking? As laborers, they probably had no personal memories of the hotel's high-society events; of dining on Chateaubriand Parisienne, mutton kidneys with mushrooms or braised sweetbreads with French peas; of six bartenders hustling to serve a crush of well-heeled theatergoers; or of an orchestra playing as tipsy socialites splashed in the marble fountain. But they must have heard stories.

And they surely knew some of the names on the Baltimore's register, the famous folk who inhabited the rooms they were now dismantling: the Roosevelts, Earharts and others. Was it just another job? Did they wonder who was responsible for, in effect, denying future Kansas Citians a priceless piece of their past?

It's possible they thought the future needed the parking lot that replaced the hotel.

The parking lot is gone now, too. City Center Square stands where the Hotel Baltimore once did. Maybe it's possible to find the spirit of Enrico Caruso in the Starbucks there.

Or you can cross the state line a few blocks into Kansas where, on a grassy island in Mission Hills, the old marble fountain from the Pompeian Room is the centerpiece. Linger there as long as the well-heeled neighbors will let you, and imagine what the fountain has seen.

SOMETHING DARK

I'm walking west on Tenth Street, just east of Main, unsure of the hour, day, the month or year. The guy ahead of me appears to be frozen in his white shoes, as if arrested by the hand-painted "danger" sign on the plywood wall he's just passed.

If the shoes and straw hat can be trusted, I'd say it is summertime. And if the warning on the temporary wall means anything, it's probably that construction is underway on the new Commerce Garage. This would suggest the year is about 1941.

I suppose someone could read the sign as a kind of message from the universe. In the summer of 1941, President Roosevelt is warning against inflation as a danger to the economy. His opponents see danger in a chief executive with too much power. And there's the dangerous possibility of war on two oceans and two continents. "I think that the international situation is more serious than the general public understands and that it is rapidly getting more so," says one congressman.

That guy ahead of me looks like he belongs to the 1937 Ford coupe with the white sidewalls parked to his left, and the universe might intend only to call attention to his failure to turn the wheels toward a downhill curb.

Perhaps something dark lurks in the idea of this new parking garage, which when completed will be among 130-some structures and lots between Oak

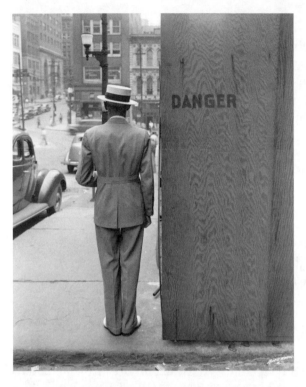

Is summer already gone? Courtesy of Missouri Valley Special Collections, Kansas City Public Library, Kansas City, Missouri.

and Central and Sixth and Fifteenth Streets that are dedicated to idle autos. But is it a fear of business lost to a lack of parking? Or is it the loss of the doctor's office, the barbershop, the hotel and the café that were removed for the parking lot?

Of course, a calendar could show summer is already gone. In which case, the danger might be nothing more than a doubtful glance or a cluck of the tongue from a passerby, aware of the fashion rule: straw hats and white clothes are not worn after Labor Day.

THE DAY THEY STOPPED THE PRESSES

Trees and shrubs on the gentle slope of Hospital Hill are showing wisps of green. They offer their springtime optimism to the downtown skyline, with that dramatic sweep of city and sky broken only by a multistory parking garage just across Gillham Road.

This must have been among the perks of a job at the newspaper plant that once operated here, at a time when daily-newspaper readers in this town still had a choice. It was surely a spirit-lifting view even on April Fool's Eve 1942, final day of that choice, when the editor of the *Kansas City Journal* wrote in a front-page column: "We had some pretty bitter things we were going to say here. We were going to raise ill-mannered hell. But it seems such a silly way to leave, and what are lawyers for, anyway?"

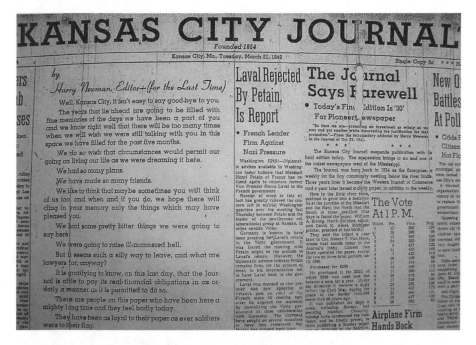

Under different names, the *Journal* had been around for eighty-eight years. *Courtesy of the author.*

Under several owners and several names—*Enterprise, Western Journal of Commerce, Journal-Post*—the *Journal* had been around for eighty-eight years. The last twenty or so, it had operated in an old auto-tractor school building with a vaguely Spanish-mission façade on the hill at Twenty-second and Oak streets.

Eighty-eight years—that's longer than the cross-town rival *Star* and long enough to cover both the Gettysburg Address and President Roosevelt's most recent "fireside chat." But there were problems of management and money, as in a long-unpaid newsprint bill for more than $200,000.

In 1942, all over America, things were changing for daily newspapers. The number of multiple-newspaper towns had dropped. The number of readers was up overall, but it was down as a percentage of population. The Depression had taken its toll on ad revenue, and more people were turning to radio for late-breaking news. Solvent dailies like the *Star* had bought their own radio stations to stay profitable. Others had merged, consolidated or had given up.

At the end an Emporia, Kansas, editorial writer suggested the *Journal* had "passed from one rich man to another like a worn-out courtesan. And

finally, without a gasp, it rolls over, stretches out and dies, with no one left to mourn its passing."

Actually, the *Journal*'s many mourners included an editor in Jefferson City, Missouri.

"It leaves Kansas City with only one newspaper," he wrote. "And it a radical Republican organ that hates Democrats like they were all thieves and scoundrels."

The reporters, editors, copy boys, pressmen, secretaries and salesmen—three hundred employees total—had been told yesterday that today would be the *Journal*'s last. Still, they had seventy thousand subscribers and one more edition.

A few took the opportunity to say goodbye in print. The women's editor reminisced about assignments: a wedding, a symphony concert, a list of best-dressed women and an election event where she was "a putative Democrat in a hotbed of rich, reactionary Republicans who were busy reforming the town."

Lookie the *Journal* Weathercock commented: "There's nothing wrong with the weather today; it's the calendar that pulled a boner. This ought to be April Fool's Day."

An associate editor bid "Good-by and good luck" on behalf of the sports editor, who was in Florida covering spring training and writing a notice that "the game scheduled for today between Louisville and the Blues was cancelled because of the weather."

Mostly it was just the news: wire reports from the war; early returns from the mayoral election; the Naval Construction Corp. recruiting at the Federal Building; an emergency appendectomy at Trinity Lutheran; a beating at Union Station; a woman entertaining her bridge club; a round-table discussion at Municipal Auditorium, titled "What Are We Fighting For?"; the "Inquiring Reporter" asking persons on the street "Do you think military training should be compulsory in Kansas City schools?"; a jailed prisoner trying to hang himself; lists of births, marriages and divorces; and obituaries.

There was plenty of irony: the listing of tomorrow's radio programming; the "to-be-continued" comics-page activities of "Dan Dunn, Secret Operative 48" and "Buck Rogers, 25th Century A.D."; and the cluelessness of Ripley's Believe It or Not: "What Tribe of People Did Not Change Their Clothes in 40 Years? Answer Tomorrow."

In the 1950s, when the *Star* was found guilty of violating the Sherman Antitrust Act for years of monopolistic business practices, the prosecution's

evidence (until a judge disallowed it) included the failure of the *Journal*. The *Star*'s editor said the *Journal* "just ran out of funds and folded." Years later, in a published history of the *Star*, that editor's grandson decided this "was far from the full or unvarnished truth."

So maybe it's not hard to empathize with the *Journal* editor on his last day mulling "pretty bitter things" he might say in print.

I picture him there on the third floor, sitting in front of a heavy, black Royal typewriter, the clacking of other Royals all around him and maybe a cigarette dangling from his lips. He's composing his farewell and gazing out the warehouse-style windows that frame the cityscape. This perch, looking downhill toward the *Star* building, could offer a momentary illusion of superiority—or a sense of forgiveness.

He types: "To our readers, a fond and long farewell and our gratitude. To our advertisers, the best of luck and prosperity unbounded. And to the *Star*, the traditional handshake at the last bell of the last round. We will be going now."

The God-Box Player

One frigid morning, I slipped a couple dollars under my coffee cup on the Harvey House counter and stepped into the chilly Union Station lobby just in time to watch a miniature Santa Fe streamliner approach its tiny depot on the Christmastime model-train layout.

It seemed a promising start to my search for the spirit of Fats Waller.

It was the same date in 1943, another unusually cold morning for December in Kansas City. The mercury touched negative two as the Santa Fe Chief slid into the sheds at Union Station.

On board in a stateroom were popular musician Fats Waller and his manager, bound to New York from California. Fats was recovering from a two-week gig in Los Angeles and a ten-day bout with the flu.

The Chief had been due in Kansas City at 3:55 a.m. but arrived a little after 5:00. Fats's manager awoke and heard choking sounds. Fats was trembling, as if he was in a dream, but he wouldn't wake up. A doctor was hustled in from General Hospital.

That evening, the page-two headline read "Fats Waller Dies Here— Noted Negro Piano Player Suffers Heart Attack."

Actually, the Jackson County coroner said, it was "acute left influenzal bronchial pneumonia." He did the autopsy, but not until Fats's 278-pound

The player piano in Union Station's lobby. *Courtesy of the author.*

body was moved from a whites-only funeral home to the Flynn-Greenstreet Mortuary in the Eighteenth and Vine neighborhood.

Hours earlier, Fats had lain awake in his stateroom as the Chief knifed through a Kansas snowstorm. The howling wind reminded him of his saxophone-playing friend Coleman Hawkins.

He said, "Hawkins is sure blowin' out there tonight."

I left the model trains and walked through shafts of sunlight that linked marble floors to huge, arched windows. Christmas trees stood about in tinseled finery. Near the center of the station a player piano sat behind black ropes, and a "Please Do Not Touch" sign sat above its animated keyboard. The piano was rolling out holiday tunes, sacred and secular.

A likely spot, I thought, for Fats's spirit to linger. Except this piano was playing "The Holly and the Ivy" instead of something like "Honeysuckle Rose," "Your Feets Too Big" or "Ain't Misbehavin.'"

Thomas Wright "Fats" Waller probably never figured Kansas City as a good place to take his last breath. There was that time in the 1930s, after a long, 643-mile road trip from Denver to Kansas City aboard Old Methuselah— the band's bus—where a canceled gig awaited him here.

On the other hand, there were good times when his old friend, Count Basie, was playing the Reno Club on Twelfth Street. Fats coveted Basie's musicians.

"Fats was crazy about that band," Basie remembered years later. "He was working in some theater downtown, I think, and as soon as his show was over, he was right back down there at the Reno. He'd come in and sit down and he was there for the evening."

The friendship dated to Harlem in the 1920s when Fats was playing organ for silent movies in the Lincoln Theatre. Basie used to sit in the first row. Fats eventually brought him up to sit next to him.

"'Don't worry about the keyboard. When you see something up there in the story on the screen, just play something that comes into your mind,'" Basie remembered Fats telling him. "That's how it was with me and Fats. That's the way he taught me, and those were the only organ lessons I ever had."

In the cavernous former waiting room at Union Station, a steady trickle of folks moved toward rides on a kid-sized train that was once a holiday fixture at Jones Department Store. I sat down on a bench, put on my headphones and listened to Fats Waller tunes.

Fats was a large man with large appetites for food, drink and women. He wrote music for the Broadway stage, Hollywood movies and recordings. He was on the road a lot and traveled to Europe twice. He's now considered one of the foremost stylists of stride piano and the first true jazz organist. He was only thirty-nine when he died.

I've always thought his showbiz persona was a little over-the-top and too much a cartoon black character. Turns out he did that for the money. Boogie-woogie was beneath him. He aspired to write like Irving Berlin and the Gershwins—what he considered serious music. The son of a Baptist preacher, his first love was the organ that he began playing as a ten-year-old in his father's church.

There's a story that, on one of his European trips, he played the massive pipe organ at the Cathedral of Notre Dame in Paris, an instrument he called "the God box." That was the greatest moment of his life, he said.

Sitting there on my bench, I was thinking about Fats lying uncomfortably awake there in his swaying stateroom, listening to the clicking rails and the Kansas wind blow like Coleman Hawkins. He was anxious to get home for Christmas, to his wife and his home on Long Island. I wondered about the God box. Near the end, does life's greatest moment replay in memory?

On my way out, I passed the player piano. One tune was just ending, and another began. It was the hymn "Rock of Ages." Not typically a Christmas song, I thought, but one I've heard at memorial services.

I could sort of imagine Union Station as a cathedral, the waiting room as nave and the lobby as a transept. And here, in the crossing, was the glossy black Baldwin. It was something less than a God box, yes, but Fats could surely make it sing.

EULOGY ON MAIN

I'm strolling a stretch of Main south of Fifty-first Street, channeling the same day in January 1945. It's a chilly winter morning. Storefronts along here—all of them restaurants now—are quiet at this hour as they surely were then as cleaners, florists and barbershops.

On the next corner, a two-story stucco house with a red-tile roof is connected by an arched breezeway to the Spanish-style Visitation Catholic Church. In 1945, it's the home of the Very Reverend Thomas B. McDonald, Visitation's founder and longtime pastor.

I'm picturing Monsignor McDonald in this house on that particular morning, after early Mass and before a 10 o'clock funeral service. Maybe he takes time to scan the news of the day. If Kansas City were Berlin, says the *Times*, the Russian Army would be just east of Boonville, Missouri, and the Americans just this side of Oakley, Kansas. There's a photo of Bennie, a black bear at the zoo, who ate cake yesterday on his first birthday. And here's a two-paragraph notice about Vice President Truman flying in for this morning's funeral service. Doesn't say where the service will be, but the monsignor already knows.

Detail of Visitation Church, near Fifty-second and Main Streets. *Courtesy of the author.*

In 1945, Thomas B. McDonald has lived sixty-eight years—most of them on this corner. It's been almost thirty years since he helped raise the beams in this church. Before that, he celebrated its first Mass in his family's home, which stood here. And before that, when this neighborhood was his father's farm, he cut wheat, tied grapevines and picked apples and cherries in the orchard. I'm imagining this as one of his more memorable days, if not an easy one.

The deceased is an ex-con, a larger-than-life character and notorious in the eyes of the national press. But the church will swell with admirers, not detractors. Thousands of them—precinct workers, judges, politicians and plain folks in rough clothes—already have filed through the mortuary up at Linwood and Main and past the open, solid-bronze casket surrounded by floral sprays—red roses, pink azaleas and white carnations—and ribbons reading "North Side Democratic club" and "Ninth Ward Democratic club." They'll overflow the sanctuary, spill into aisles and out onto sidewalks and street. They'll be the grateful ones, not the reformers.

"Some always look for the evil," Monsignor McDonald will tell them, after the altar lights are lighted and the casket is blessed, after the "Ave Maria" and the Missa cantata. "They never look for the good qualities."

He'll say that this man was at church every morning for thirty years; that he was a loyal friend with a noble heart; a man who gave to charity, who never turned down a request for help and who never maliciously injured anyone; a man whose word was above reproach; and a man who helped hundreds during the days of the Depression.

"In regarding his life it would be well to recall the injunction, 'Let him who is without sin cast the first stone,'" he'll say.

The vice president will be sitting down in front, near the family and closest friends. The monsignor knows the connection, and the connection will be the story. The story behind the story is the other truth: the fraud, the violence and the national embarrassment. "We all have faults. We are all human beings," he'll tell them. "A man who tries to find happiness through money or power never finds it."

"We want God to have mercy on his soul. We want God to forget his faults. I trust that each and every one will say a prayer for him."

After the pews empty, after a hundred cars fall in behind the departing hearse, after Truman rushes back to Municipal Airport and these blocks of Main are quiet again, the story in evening papers from Fresno to El Paso to Syracuse will begin: "The vice president of the United States flew to Kansas City

today in an Army plane to attend the funeral rites for Thomas J. Pendergast, the political Caesar who lifted him into the U.S. Senate eleven years ago."

And a few will add this quote: "Everything the Monsignor said was true," Truman said. "Pendergast was my friend, and I was his."

STANDING ON THE CORNER

The other morning, the dog took me for a walk in a little park east of downtown. It's a pleasant place, grassy and treed, and as we walked, I was remembering a man I met several years ago.

He was a conventioneer from back East, on his first trip to Kansas City, and during a break in his schedule, he had made a pilgrimage from his hotel to stand on a particular street corner. It was possibly the one Kansas City landmark he had ever heard about. When he found it no longer existed he was incredulous.

"How could you obliterate Twelfth and Vine?" he demanded to know.

Urban redevelopment, I said.

Today, the guy would be happier, I think. The little park where the dog and I walked has replaced a decrepit housing project. He could, as other tourists do, have his photo snapped there under a sign where the corner used to be, read about the cultural significance of that intersection and notice that the park is shaped like a grand piano.

And like me, he might want to imagine a bit of musical time-traveling.

The sign where the corner used to be. *Courtesy of the author.*

My travels would begin across the street, on the south side of Twelfth where Vine is now just an indentation in the sidewalk. It's July in the first post-war summer of 1946. The intersection of Twelfth and Vine is part of a busy clutch of streetcar shops stretching east from the Paseo. Within one block are groceries, shoeshine parlors, beauty salons, doctors, dentists and second-floor apartments.

There's the OK Bargain Store and the Busy Bee Lunch, the Fern Laundry, the Vine Street Tavern, the Midway Loan Office, the New York Shoe Shop, MK's Everything Store, the Last Round Up restaurant, the Central Barber Shop, Midway Men's Ready to Wear, the Golden Star Café, Berryman's Pharmacy, Red Crown Liquors, Velvet Freeze and a branch of the post office.

Doors are open, allowing the summer breeze in and whatever's inside, out: voices, kitchen aromas or music. Melodies drift from MK's Everything Store, a variety shop that specializes in phonograph records. The latest are by Nat King Cole, Big Maceo, Erskine Hawkins, T-Bone Walker, Charles Brown, Billy Eckstine, Louis Jordan, the Soul Stirrers, the Ink Spots, Gene Krupa, Sister Rosetta Tharpe and Lionel Hampton.

The songs are about love, deceit, Jesus and a mean old world; about low-down women and a sugar-fruity Petootie; about a lonesome moon, a prisoner of love and a honey with no money; about going to see a gypsy and traveling the highway that's the best.

The proprietor of MK's Everything Store is a thirty-four-year-old man named Myron Kimber, the son of a coal miner from Alabama who migrated to work the mines of southeast Kansas.

Kimber (some might say he resembles Jay McShann) has been in Kansas City since the early thirties when he drove a cab for Sam's Taxi Service in the Eighteenth and Vine neighborhood. He's also loaded freight for the Wabash Railroad and managed a hotel on Tenth Street. He advertises MK's Everything Store (1607 East Twelfth, HArrison 8994) in the *Kansas City Call*: "Latest Record Hits. Call Us For Truck Hauling."

In future years, his business will expand to include his own taxi service and real estate interests. He'll come to be known as "the Mayor of Twelfth Street."

My time travels would have to include a visit with Myron Kimber. I want to hear his cabbie stories from the old days around Eighteenth and Vine. But I need to remember that I'm carrying my own time-traveling baggage—my

twenty-first century sensibilities. In July 1946, Myron Kimber, his customers and the folks walking past MK's Everything Store on Twelfth Street have a different set of realities shaping their thoughts.

For instance, the recent reelection of the governor of Georgia, who campaigned on a theme of white supremacy, was quoted as saying, "A nigger's place is to come in the back door, hold his hat in his hand, and say 'gee' and 'haw' to a horse." In another reelection campaign, a senator from Mississippi declared "every red-blooded Anglo-Saxon Mississippian will use every means possible to keep Negroes from voting."

In St. Louis, a burning cross recently was discovered on a playground recently opened to Negro children. There have been newspaper headlines like "FORCED TO MARRY NEGRO, WOMAN SAYS." Close to home, the annual Jackson County Sheriff's picnic has been moved from Fairyland Park to another park. The sheriff says he wasn't aware that Fairyland Park bars Negroes.

So I'll listen carefully as I approach the MK Everything Store, where tunes waft through the open door toward the corner of Twelfth and Vine. If I'm not mistaken, that's the Soul Stirrers: "Sometimes I feel like the weight of the world is on my shoulders. I'm like a ship that's tossed and driven by an angry sea."

ON VACATION, OUT OF POSITION

I had wandered into the Hotel Muehlebach through its original Twelfth Street entrance, between Wyandotte and Baltimore Streets. The old hotel is now an appendage of a newer complex that straddles two downtown blocks, and the corporate owner has shifted business to a more contemporary lobby up the hill. It seemed a little like keeping your old great aunt, still gracious and vital, in a shed out back so she won't embarrass visitors.

For my visit, the old lobby's chandeliers illuminated the gorgeous dark woodwork, the mosaic tile floors smoothed by decades of footsteps and the front desk with its empty cubbyholes for room keys. When I pressed an elevator button, a bell dinged and the ornate door slid open, but the car went nowhere. A tarnished brass plate above the elevator displayed "Terrace Grill" as one floor down, but I walked downstairs and found no such place. I could hear a murmur of voices somewhere, but I saw no one.

Up on the mezzanine, a set of French doors overlooked the canopy sheltering the hotel's Baltimore Street entrance. Years ago, a sign above

Herb Treat and the
Hotel Muehlebach
canopy. *Courtesy of the
author.*

the canopy advertised the Terrace Grill as a restaurant with live music and dancing. Lingering at the window, I tried to imagine the sign in those rainy early hours of April 19, 1947.

Charles Herbert Treat had checked into the Muehlebach at 3:48 a.m. on April 18. He had flown in from New York and had a layover en route to Phoenix. Someone at the front desk looked at Treat and summoned the hotel doctor and a wheelchair. The doctor prescribed pills. The wheelchair carried him to room 932, high above the Terrace Grill sign and its notice of featured entertainment.

Chances are good he would have remembered the Bernie Cummins Orchestra.

Bernard Joseph Cummins was near the end of a three-week stay at the Muehlebach, billed as one of the "All-Time Favorites. High on the Popularity Poll of Terrace Grill Diners and Dancers."

The Bernie Cummins Orchestra had been one of the hot dance bands of the 1920s, recording tunes like "Make My Cot Where the Cot-Cot-Cotton Grows" and "Livin' in the Sunlight, Lovin' in the Moonlight." Now Cummins made his living on the road in big-city hotels and small-town dance halls, playing a mix of old and new in what he called "businessman's tempo"—"for the ears and feet rather than just the ears." There were three shows daily in the Terrace Grill.

Cummins had Valentino's looks, didn't smoke or drink and was a huge sports fan. He'd played high school football, basketball and baseball and

once hoped to play for Knute Rockne at Notre Dame. A leg injury pushed him to music.

He'd won some notoriety for correctly predicting pennant winners and boxing champions. He shot golf in the seventies and was known to carry a newspaper clipping about his hole-in-one in Tennessee. His all-time football backfield included Jim Thorpe, Bronko Nagurski and George Gippe.

Most likely he had heard of Charles Herbert Treat.

"The Team of Destiny" was a name given Princeton's 1922 football squad by sportswriter Grantland Rice. They were undefeated but rarely favored. A New York newspaper cartoon headlined "Some Football Giants of 1922" included a scowling, curly haired player swooping in for a kill, above this caption: "Herbert Treat, Princeton tackle, roves all over the field and is as fast as any of the ends. He's 6 feet 3 inches tall."

Football innovator and sportswriter Walter Camp called Treat rangy and powerful, "particularly strong in diagnosing the play quickly and in never being drawn too far out of position. For a strong man, he is extremely fast."

Herb Treat remained in room 932 all day.

Four years earlier, while working at a wartime Massachusetts shipyard, he'd been hit by a car and critically injured. Recently he'd spent months in a sanitarium, receiving treatment for incurable tuberculosis. He was a long way from strong or fast, but maybe he could still sense that he was too far out of position.

Sometime after midnight, after the Bernie Cummins Orchestra had played its theme song, "Dark Eyes," and signed off for the evening, the contents of room 932 included blood-stained clothing scattered around on furniture; a fifth of whiskey, nearly empty, on the desk; a wallet containing $215.80 and a newspaper clipping naming the All-American football team of 1922; and a member of that team, naked, scribbling a note to his wife: "On vacation—couldn't stand it."

He laid the note on the dresser and put on his overcoat. It was raining outside.

I want to connect these two men, to bring them together under better circumstances, perhaps to share news clippings or 1920s memories or chat about sports and music. Things might have turned out differently, at least for a while.

As it was, Herb Treat's last act before his overcoat-clad body landed face-down atop the Baltimore Street canopy was to crash through the Terrace Grill sign, erasing the notice of the Bernie Cummins Orchestra.

A Union Man Speaks Out

Standing in the middle of Highland Avenue one Saturday afternoon, admiring the pink-stucco façade of an old union hall, I suddenly heard the voice of Count Basie.

"I am a union man," said the Count, speaking across time from late January 1947. "I will never cross a picket line to play for anyone."

Just then, a woman came up the sidewalk; she was white, middle-aged and bundled against the cold in a fuzzy coat and hat. "Is anyone in there?" she asked before trying the door, which was locked. "They said they'd be here between 10 and 1." She shrugged and walked away.

Must be from out of town, I thought. Not much life around here until later, sometime after midnight. The witching hour for the early morning jam session that attracts jazz musicians and jazz lovers to the second floor of this union hall like June bugs to a porch light.

Basie was no stranger to this building nor were the other creators of the swinging, blues-based music we call Kansas City jazz; they were all members of the American Federation of Musicians, Local 627.

In January 1947, the Count Basie big band was a decade removed from Kansas City, having left town for the New York City big time just before recording a hit with "One O'clock Jump."

Jazz was changing. The new sound would come to be known as bebop, as in Charlie Parker, Dizzy Gillespie and others. Lean times were bearing down on the big dance bands like Basie's. Society was changing, too. In three

Count Basie was no stranger to this building. *Courtesy of the author.*

months, a black man finally would be playing major-league baseball. Racial barriers were starting to crumble ever so slowly.

In Kansas City, blacks now could attend concerts with whites at Municipal Auditorium, but often there were blocs of seats assigned to their race, usually at the back of the hall. Because the ten-year-old Municipal Auditorium was city owned, this did not sit well with black taxpayers. City leaders insisted they were just landlords; they didn't set policy. Promoters who rented the venue said the city suggested they "follow the custom in the seating of Negroes."

The National Association for the Advancement of Colored People had been picketing all segregated events at the auditorium. Many of these events were sponsored by two local promoters, John Antonello and Jimmy Nixon of A&N Presentations.

For the last Saturday in January, A&N Presentations had rented the auditorium for a big dance with music by Count Basie. A few days before the event, A&N received a telegram from Basie: He would not cross a picket line. There would be no show at the auditorium.

Antonello said he had no interest in being a social pioneer. He said it was up to the city to make a clear policy of no segregated seating in Municipal Auditorium. There would be no such policy for four more years.

Meantime, the Count and his musicians put on a show for a mixed audience across the river in Kansas City, Kansas. The policy at Memorial Hall was clear.

Basie's autobiography, *Good Morning Blues*, was published in 1985, the year after he died. As one reviewer put it, hardships and indignities of the Jim Crow era were "not ignored or written out of history, but they are certainly not dwelt upon." So it's interesting to listen to the Count speaking from 1947.

> *Some day promoters in Kansas City will learn they are way behind the times in charging people the same prices of admission and then shunning them off in special sections because of color or religion. I want the world to know that I do not approve of segregating any part of the American people. Kansas City ought to wake up.*

It's past midnight. Everyone's fully awake down at the old union hall at Nineteenth and Highland. Upstairs—where the Count played piano, where Dizzy and Bird first met, where linger the spirits of Prez and Hootie, Buck and Hot Lips, Big Joe and Mr. Five-by-Five and all the others—the musicians are tuning up. It's 1 o'clock. Time to get jumpin'.

The Wisconsin "Shangri-La"

The northern entrance to downtown, where Grand Boulevard receives Admiral Boulevard and sends it westward as Seventh Street, seems shamefully underdeveloped. There's a scattering of modest buildings with plenty of vacant asphalt. It's a gateway without distinction.

So I was looking at the northwest corner—a parking lot that backs to a car-rental outlet—and wondering what a three-story, turreted, stone-and-shingle Victorian house would do for the neighborhood. It would be maybe ten thousand square feet or so with a slate roof, big veranda and several porches. Inside, there would be some stained Venetian glass, pine and oiled hardwoods, wainscoting, a few Arabesque archways, some onyx, marble, bronze and maybe a hand-carved, highly polished, white-oak staircase.

I don't mean a twenty-first-century reproduction. I mean something authentic, original and historic with nineteenth-century cultural resonance. It would be a house with some miles on it, literally. In other words, something like what once stood here.

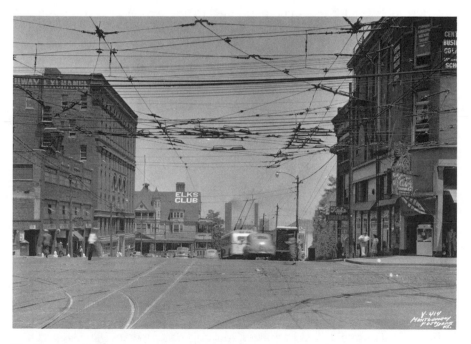

The Elks Club at the corner of Seventh and Grand in the late 1940s. *Courtesy of Missouri Valley Special Collections, Kansas City Public Library, Kansas City, Missouri.*

My streetside daydream coincided with an obscure anniversary in the life of that house; a life that began in Chicago and ended on this corner sixty-eight years later. More than fifty of those years were spent as clubhouse to the Benevolent Protective Order of Elks no. 26. In May 1948, the Elks Club lost its charter. An earlier police raid had confiscated seventeen slot machines from the basement of the house. Then, the city revoked the club's liquor license.

That the relatively benign Elks would be busted for gambling in their own clubhouse seems a comment on the long arm of the law under the reformers that replaced Boss Tom Pendergast and a testament to Pendergast's lasting influence three years after his death. But then, Pendergast was an Elk, as was his man Harry Truman.

When Truman was still selling neckties for a living, his old world war buddies once reunited at the Elks Club. It was 1921, early in Prohibition, but what's a reunion without whiskey or a good food-and-glassware fight? Truman, the outfit's former captain, got a bill for $167.80 in damages.

Still, the clubhouse was dear to Elks. Years after the house was demolished, one Elk in the funeral business ran a nostalgic newspaper ad remembering it as a personal "Shangri-la." He mentioned the house's origins at the World's Fair, "which, as everyone knows, was in St. Louis in 1904."

Actually, it was 1893 in Chicago. The World's Columbian Exposition, marking the 400th anniversary of Columbus's arrival in the New World. It was the fair that gave us Shredded Wheat, Cracker Jack, the Ferris wheel and the idea that American-ness was created at the intersection of civilization and wilderness.

Individual state buildings displayed the fruits of local industry, agriculture and the arts. Among these, the Wisconsin Building stood out for its resemblance to a private home. Fairgoers found it an oasis amid the high-minded opulence of "The White City," a place to smoke, lounge in parlor chairs and eat box lunches on the wide veranda. Judges gave the Wisconsin Building first prize for practical design.

After the fair closed, much of it went to auction: flagpoles, ornaments, furniture, artwork and even whole buildings. The Wisconsin Building was expected to remain, perhaps as "a place where social, literary and scientific clubs will meet," as one observer suggested.

Instead, it came here, in pieces, on railroad flatcars. J.C. Rogers, a Wamego, Kansas, businessman with Kansas City connections, bought the house and other salvage, including paintings from the Government Building

and aquarium glass from the Fisheries Building. Many items were reused—and can be seen today—in a theater he built in Wamego.

Rogers saw this corner of Seventh and Grand as the ideal site for his Wisconsin Building. It would be a fine public club for gentlemen with a bar built of aquarium glass, with swimming fish.

The Wisconsin Club never took hold, and Rogers sold it. For a short time, the Midland Hotel across the street used the building for overflow business, such as the traveling cigar salesman who drank heavily for a week until he ran out of money and then slit his throat and both wrists, stabbed his legs and torso with a penknife and tried to shoot himself twice in the head.

In 1898, the Elks moved in. They built an annex and added some porches. Years later, when the Wisconsin Building was host to the seventieth national convention of Elks, it was called "one of the most beautiful fraternal clubhouses in the country."

I'm guessing the Elks Club would have been among the sights to see for visiting Wisconsinites. State delegates, for example, who helped nominate Herbert Hoover at the 1928 Republican Convention, or Badger fans who rooted their team past Washington State in the 1941 NCAA Basketball Championship at Municipal Auditorium.

Maybe even a few old-timers who—upon climbing the front steps and seeing the Lake Superior brownstone and the Menominee brick, the state coat-of-arms over the entrance and the inlaid WISCONSIN in the threshold tile—perhaps would recall a summer day in Chicago in 1893.

After the slot-machine fiasco, the Elks regained their charter in the fall of 1948. Three years later, they followed the city's southward migration to a clubhouse on Armour Boulevard.

The City Union Mission took over the Wisconsin Building, pledging to continue its longtime work: feeding the hungry, clothing the naked, sheltering the homeless and preaching the gospel to the poor. Workers transformed the bar into a youth chapel. Eventually, the City Union Mission moved on, too.

Part of Elkdom is the traditional 11 o'clock toast to "absent brothers." As one version of the toast says, "it is the golden hour of recollection, the homecoming of those who wander, the mystic roll call of those who will come no more."

Victorian architecture was absent from the worldview of midcentury urban planners. A group of downtown Kansas City businessmen bought the

old Wisconsin Building, had it dismantled a second and final time and put up a parking lot.

I'm wondering whether any of them were Elks, and in the golden hour of recollection, after the last chunk of Lake Superior brownstone was hauled away, whether anyone raised a glass.

FALL IN PETTICOAT LANE

The autumn sky is cloudless, and wind is scouring downtown streets. Dodging gusts, a man loads two gangly purple orchids into a van parked in Petticoat Lane, just outside the old facade of the Harzfeld's building, which is now a component of a larger office complex.

Through the windows you can see the sterile lobby with its bank of elevators, and you think of Thomas Hart Benton's mural—*Achelous and Hercules*—that used to hang above the elevators of the old Harzfeld's. You might drift into wonderment about a time when famous muralists were commissioned by retail stores, or you might think about the elevators.

It was an October Thursday in 1949. On Thursdays, Harzfeld's opened for business at noon. Every Thursday morning, men from the Otis Company came to inspect the elevators.

Siegmund Harzfeld was a forward-looking man with no patience for pessimists. He loved beauty. He was a major benefactor of the Kansas

Façade of the old Harzfeld's. *Courtesy of the author.*

102

City Philharmonic Orchestra and worked to bring classical music to schoolchildren. Childless, "Sieg" and his wife traveled often to Europe in the years between the world wars.

"Reports that times are not getting better are so much nonsense," he said in 1933, in the darkest depths of the Great Depression. "If these pessimists could also take a trip to Europe they would learn that America isn't in such a terrible condition."

At that time, Harzfeld had been in Kansas City for more than forty years as the owner of the country's oldest ready-to-wear clothing store exclusively for women.

"My ambition has been to make Kansas City so much the best place that it no longer will be necessary for the best-dressed women in Kansas City to buy their clothing anywhere but in their own town," he said.

His original store, the Parisian Cloak Company, was on Main Street. In 1913, he moved to a new building around the corner. The ten-story Harzfeld's featured expansive windows, brown carpets with soft-yellow walls and display cabinets of Circassian walnut.

Sieg Harzfeld made it his morning routine, after clearing his desk of paperwork, to walk each floor of his store, listening to employees and making suggestions. In the afternoons, he did it again. Round-faced, balding and bespectacled, he was said to be a kind boss—almost fatherly.

"When a man spends almost as many hours in his store as he does at home it should be a congenial place and the atmosphere should be cheery," he once said. "The customers are your visitors."

The customers on that Thursday needed something to wear to the American Royal Ball, to the Philharmonic concert, for dancing to Claude Thornhill at the Pla-Mor Ballroom, the live NBC radio broadcast of *Truth or Consequences* at Municipal Auditorium or maybe just to the movies—perhaps *White Heat*, *The Red Shoes* or *She Wore a Yellow Ribbon*.

The afternoon was warm. The sound of the World Series—Preacher Roe nursing a 1–0 lead for the Dodgers in Yankee Stadium—drifted from open car windows in and around Petticoat Lane, the two-block stretch of Eleventh Street between Grand and Main that was the sweet-spot of Kansas City fashion.

In fashion that fall was the small waist, the smooth hip line, the tilted hat, the button-down dress and the fitted coat. From Emery, Bird, Thayer to Taylor's (soon to become Macy's), Woolf Brothers to Kline's, Chandler's to Harzfeld's and beyond, the customers found alligator-lizard pumps with

matching handbags, velvet suits with rhinestone buttons, lambskin gloves, jeweled silk hats, wool cardigans and furs of South American otter.

Inside Harzfeld's, they found black-suede opera pumps and green-velvet party blouses; tailored, navy-blue sharkskin suits and brown wool jerseys; Russian squirrel minks and nylon satin corsets. ("Lifts in front. Spanks in back.")

At about 3:00 p.m. the elevator doors opened on the seventh floor (Alterations, Fur Repairs), and the manager of the A&P grocery in Odessa, Missouri, got on with his wife and three small children. A woman operating the lift called out each floor as it descended to six (Sport Shop, Millinery), to five (Baby Shop, Toy Shop, Teens, Maternity) and to four (Shoes, Lingerie, Uniforms), loading and unloading.

When the doors closed at the fourth floor, the operator and her twenty passengers fully expected to stop at three. Then, high up in the elevator shaft, a steel plate cracked and broke free of its bolts.

Sirens drew a crowd into Petticoat Lane. Police, several ambulances and a hook-and-ladder fire truck were soon surrounded by the curious and the alarmed. Traffic halted.

Inside, firemen had chopped through a wall just below the ceiling of the second floor, where the elevator now rested. A safety brake had caught the car after a twenty-four-foot drop. Victims lay about on stretchers. The final toll: fractures to two legs, six ankles, four feet and one back; two cases of shock; several cuts and bruises; but no fatalities.

The A&P manager sat on a chair, nursing two swollen ankles, with his seventeen-month-old son on his lap crying but, like his siblings, unhurt.

"Probably no one realized the elevator was going too fast," the man said. "Then it stopped with a jerk. We all tumbled to the floor. The impact was so hard that we were all sort of in a state of shock for a moment."

You're drawn to a mental image of a concerned Sieg Harzfeld amid the chaos, bending over each victim, assuaging his alarmed visitors. Except that, by the fall of 1949, Sieg Harzfeld had been dead more than five years.

In days after the accident, Harzfeld's offered little beyond a promotion of black crepe dresses ("black dramatized with color…but black, by all means"). The official company word, tucked into an inside-page newspaper article, was that repairs would be made soon, and the store had four other working elevators.

You're left to wonder whether Sieg bequeathed his "cheery atmosphere" to his employees, or whether customers of 1949—an age when epic artwork hung above clothing-store elevators—understood that things weren't really so bad.

Chapter 4

1950s

CHRISTMAS 1950

It was a Christmas Seal—a gummed stamp, tattered with age, a half inch by three-quarters and edged in green and red. At its center were three child angels: one flutist, one harpist and one singer. At the bottom, "Greetings" and the double-barred cross of the National Tuberculosis Association. At the top, "1950." The seed of my daydream.

In the first silent, starry hours, a child is born. It's a boy. The father treads the waiting room of Trinity Lutheran hospital. Outside, someone breaks a window on his car and steals his carpenter's tools.

Over in Independence, a phone rings. It's General Omar Bradley calling the president of the United States: soldiers pinned down on a North Korean beach have been evacuated.

Someone jimmies a side door at St. Mark's English Lutheran, ransacks an office and fingers a hundred sealed envelopes containing $138 in offerings from the midnight service.

At 5:00 a.m., the temperature is thirty-four degrees.

At sunrise service at Broadway Baptist, the pastor says the angel's Bethlehem message—"fear not"—was meant not just for Christ's birth, but also for the twentieth century with its atom bombs.

Sixty post office trucks fan out with last-minute packages. Many packages carry green-and-red Christmas seals. Drivers have volunteered.

Many packages carry green-and-red Christmas seals. *Courtesy of the author.*

House windows reveal glimpses of wreath, pink-flocked Christmas trees and robed figures with new baby dolls, wind-up donkeys, eight-millimeter movie cameras, Red Ranger jeweled holsters with nickel-plated pistols, Perry Como records, Western Flyer bikes, keys to new Studebakers, Loafer Sox, Erector sets.

The ornament-crusted Truman tree stands in a bay window. The president opens gifts from his wife and daughter—clothes and books, including Will Durant's *Age of Faith.*

Strangers carry gifts to St. Joseph's Home for Orphans: clothing, dolls and small amounts of cash for a baby girl. She was found over the weekend in a basket on the front step.

A small boy shows off his new wristwatch. Its time is incorrect. Someone suggests he set it by the clock on the mantel.

The temperature at 9:00 a.m. is forty degrees.

At 9:17, President Truman leaves the house on his morning walk. He wears a bowtie, dark overcoat and hat and carries a cane. Secret Service

men follow, along with newsmen. He tells them, "This saving of our men in this isolated beachhead is the best Christmas present I have had." He walks briskly, 117 steps per minute, for eighteen blocks.

Kitchens unwrap aromas of smoked ham, spiced peaches, brandied mincemeat, nut bread and fruitcake. Someone finds the boy's wristwatch on the mantel, by the clock, where he set it.

At the orphanage, a young girl and a man visit the doorstep baby. He says he's the baby's father. He hasn't seen the mother; they divorced in February after five years of marriage. The girl, oldest of four, wants to play with the baby.

Dinner is served at the City Union Mission. Turkey and trimmings for 650 people. There are 400 more at the Helping Hand Institute.

At noon, the temperature is fifty-six. A man looks out his window and sees a large bird perched in a pear tree. It looks like some kind of hawk or owl or falcon. He thinks it might be hurt, maybe shot by neighborhood kids. The bird hops to a woodpile. The man throws a blanket over it and carries it to the garage.

A phone rings. Two boys, high school students, are calling home from Springfield. Three weeks ago, they left town without notice, hoping to see the world. There was a search from Arizona to Maryland. Now they say they're ready to come home.

The president says he needs to fly back to Washington tomorrow instead of the day after. The newsmen wonder about General MacArthur's warning: communist "secret political and military decisions of enormous scope."

At 3:00 p.m., the temperature is sixty-five. Skies are clear. A man shoots a hole-in-one on the ninth hole at Swope Park no. 2 and finishes with seventy-three. The zoo crowd is the largest on Christmas since Pearl Harbor.

Cars and pedestrians stream past the Truman home, snapping pictures, pointing at the bay-window tree and remembering last week's proclamation:

> *Whereas, recent events in Korea and elsewhere constitute a grave threat to the peace of the world…Whereas, world conquest by Communist imperialism is the goal of the forces of aggression that have been loosed upon the world… Now, therefore, I, Harry S. Truman, President of the United States of America, do proclaim the existence of a national emergency.*

A traditional Christmas feast begins at the Hotel Muehlebach's Terrace Grill. Bernie Cummins and his Famous Orchestra will play until 1:00 a.m.

At 6 o'clock, the temperature is fifty-seven. Crossing a street, an old man falls and breaks his right hip. Small television screens flicker. They show

a grainy John Cameron Swayze and a fuzzy gray-and-white beachhead in North Korea. Later, it will be Arthur Godfrey's *Talent Scouts*.

Motorists creep the streets, ogling colored lights on the Country Club Plaza and in far-flung residential districts. Seven are arrested, five for driving carelessly and two for driving drunk. At the Paseo YMCA, high school football players sing carols. Someone plays a Christmas medley on an accordion. Applause fills the Music Hall for a musical satire set in 2000 AD about a comet that freezes Earth. Voices float from radios: *The Lone Ranger*; Edward R. Murrow; the chief of police, who says sirens and factory whistles will blow around noon tomorrow for a three-minute atom-bomb air-raid test. Motorists should pull over and stop.

A bus from Memphis swings into the Union Bus Terminal. A young marine steps off. Not three weeks ago, he lay bleeding in a North Korean foxhole. His left arm is in a cast. A bus from Springfield pulls in. Two high school boys climb down with memories of hitchhiking, riding freight trains and working for meals in bowling alleys and on farms. One says, "Hello Pop."

An infant boy dies at St. Joseph Hospital. He was the only survivor among triplets born last week, three months premature.

At 9 o'clock, the temperature is thirty-two. The radio voice now belongs to King George VI. It's his annual Christmas message. "If our world is to survive in any sense that makes survival worthwhile, it must learn to love, not to hate; to create, not destroy," he says.

The president turns in. He might read himself to sleep with his new book, *The Age of Faith*, and perhaps linger on one passage: "Men must learn to kill with a good conscience if they are to fight successful wars."

The second show begins at the Terrace Grill. Bernie Cummins and his Famous Orchestra jump into their final set.

At midnight, the temperature is twenty-three. The sky is starless.

The forecast is light snow, colder.

THE LAST CAR

The plaque at the base of the Town of Kansas Bridge, which provides pedestrian access to the downtown riverfront, displays the high-water level of the Missouri River during the great flood of 1951. The dogs and I sometimes walk along the riverfront trail. The line on the plaque hits me just below chest-level. I look at the line, and I look at the dogs and wonder.

This wasn't where floodwaters were deepest. *Courtesy of the author.*

But this wasn't where the floodwaters were deepest. That was along the Kansas, or Kaw, River, several blocks away in the industrial West Bottoms, which was then site of the stockyards and home to hundreds of captive animals.

He had been born a pig, with a pig's playful nature, a pig's keen sense of smell and a pig's intelligence. Then he went to market and became a hog—a fat, black hog.

As a hog, he was just one of thousands in the pens of the Kansas City stockyards that summer, when the rains fell, the Kaw River rose and the streets of towns and cities upstream from Kansas City filled with several feet of its brown water.

A day was defined by hot sun, cool mud and bristly, shoulder-to-shoulder proximity to other pigs-turned-hogs; by slats of wood through which he could see nothing but more of the same; by a symphony of grunts, squeals and different creature voices; by a slightly disconcerting smell drifting from buildings in the near distance; and by a man bringing food regularly.

All that changed when the swollen Kaw climbed over Kansas City dikes and brown water began to seep into the pen. It was Friday, July 13, 1951.

But he didn't know that—he just knew water was rising over his feet.

The flood raced through the West Bottoms, overflowing sewers, filling basements, swallowing parked cars, climbing stairs in warehouses and office buildings and trapping people on upper floors who had lingered to salvage cash, company records and merchandise. The surging water, already full of tree limbs, oil, lumber and cans, picked up paper, office equipment and animals.

Stockyard workers frantically herded frightened sheep, cattle and hogs to the upper floors of the American Royal Building. Many, trapped in pens, drowned.

Residents evacuated low-lying homes. Buildings on Southwest Boulevard caught fire when an oil tank floated against a power line. Trains stopped running, stranding passengers in Union Station. Streetcars and buses cut back service. The city asked that businesses close in order to conserve drinking water.

The fat, black hog knew none of this—he just knew he had to keep swimming.

The downtown bluff above the West Bottoms provided a flood panorama for rubberneckers with binoculars. They watched a torrent of muddy water pour over a dike into the Missouri River, with its current muscling a short chain of half-submerged boxcars a hundred yards down their track. An outboard motorboat, straining upstream, sat stationary as a canary in a headwind. Other boats rescued workers from upper-story windows. A slab of driftwood carried a live hog.

And there was another hog, swimming neck-and-neck alongside a man; and three more, churning through the front door of a warehouse, using the rising water to reach the second floor. Others were swimming to the roofs of low buildings. The rubberneckers cheered them on.

One fat, black hog swam across the current to a boardwalk created by a long line of boxcars with tops near waterline. Each time he got close enough to climb to safety, the current swept him along, down the line of boxcars.

"That's the last car, buddy," one rubbernecker shouted. "You'd better grab on."

The fat, black hog could not grab on. There was nothing now between him and the Missouri River.

"He's a goner now," shouted another.

Then the hog stood up. Someone had abandoned an automobile in just the right spot, inches below the surface of the water.

He didn't know that—he just knew he could stop swimming.

The Missouri River, engorged with the Kaw floodwaters, crested early the morning of the 14th and then slowly receded as the Kaw returned to its banks. In the coming days, men would find mud-caked cars, collapsed buildings and the bodies of dead animals littering the streets of the West Bottoms. They would rescue animals from rooftop perches and relocate them to pens and feedlots elsewhere. And in time, the packing plants would be back in business.

The fat, black hog didn't know this—but he knew he could swim.

Once Upon a Time in the Castle

The old Gothic building still stands on East Meyer Boulevard; it is slightly weary-looking but still in service to education. It's now known as the Afrikan Centered Education Collegium Campus, a contract school within the Kansas City School District.

The school motto is "Seeking the wisdom of the ancestors to build a new future."

The former Southeast High School. *Courtesy of the author.*

It might seem a long way from here to when this was known as "the castle" and students were "knights and ladies"; when the student council was the Round Table; the newspaper, the *Tower*; the yearbook, *Crusader*; and athletic teams were the Knights.

"Be a member of the construction gang and not the wrecking crew," said Harry McMillan, who became principal here in 1940, when it was Southeast High School. It was an admonishment heard every year by the knights and ladies of the castle. And despite the noble motifs, Mr. McMillan's homily suggested his familiarity with at least the potential for bad behavior.

It was surely on his mind in the fall of 1953, as the big game approached.

The football Knights were a juggernaut that year. It was the era of two-position players, helmets with no face protection and 150-pound linemen. But Southeast excelled at the running game, with six first-team all-leaguers and an all-American tailback.

They were undefeated in the regular season, with five shutouts in eight games and a 40–0 romp over Southwest for the Interscholastic League championship at Blues Stadium. Even before their final game, the Knights were being called one of the best teams in area history. For the mythical city championship, they would play Rockhurst, champs of the Catholic League, on November 12 on Rockhurst's own field.

Prepared for victory and perhaps anxious about what might happen on another school's campus, Mr. McMillan made a pregame promise to his knights and ladies. If they would remain orderly after the game—leaving the goalposts standing—he would buy the goalposts for them.

It was a world of glee clubs and letter sweaters, chaperons and cherry phosphates, white-buck shoes and cuffed blue jeans, chili suppers and Teen Town Dances and victory bonfires.

Outside the castle the night after Southeast beat Rockhurst 48–13, four hundred knights and ladies snake-danced and sang as their champions set torches to a pile of brush, made speeches and Mr. McMillan vowed to keep his promise.

And despite a temporary setback—Rockhurst's goalposts turned out to be iron—he delivered. Wooden goalposts from Blues Stadium arrived at Southeast the next week, where the woodworking class processed them into 1,400 pieces—one for each knight and lady.

It was an Ozzie-and-Harriet world with a Doris Day soundtrack. But it was also a separate-but-equal world; a world that would change before the end of the school year.

The week before the city championship, the Kansas City Board of Education had taken up a proposal to build three new athletic fields for its high schools, one at Southeast, one at East and one at Lincoln. Lincoln's would have fewer bleachers, the proposal said, because fewer people would attend those games.

In the fall of 1953, Lincoln was one of two public high schools in the city that were not eligible for the Interscholastic League championship or the mythical citywide championship. Although Rockhurst, a private school, had three black players on its football team, the only public options for Negroes were Lincoln and R.T. Coles, and they could play only teams from other Negro schools in Kansas, Missouri, Arkansas and Oklahoma.

In the spring of 1954, the U.S. Supreme Court decision—"separate educational facilities are inherently unequal"—became a prelude to a future of racial tensions, misunderstandings and ultimately the transformation of city neighborhoods nationwide.

And the medieval motifs of Southeast High would lose relevance in this new world.

The surviving members of the Southeast class of '54 are in their seventies now. They still gather en mass for reunions or in small groups for coffee. They maintain a website dedicated to their lives, past and present. They remember their championship season and the principal who kept his promise to them. And they also recall another of his admonishments: "Don't let it be said, and said to your shame, that all was beauty here until you came."

Some of them might say the old castle up on East Meyer Boulevard lost its beauty long ago. Beauty, of course, is in the eyes of the beholder.

Students at the Afrikan Centered Education Campus wear button-down shirts and blazers. They study calculus, world geography, political science and speech. They also study African literature, Nile Valley civilizations and African-American music traditions. One day, perhaps in that new future of their school motto, they'll look back on their time in the castle and recall their own season of victory.

THE BULL AND THE ELEPHANT

In Mulkey Square, the little bluff-top park tucked away near Thirteenth and Summit Streets, families picnic and play softball beneath a huge, fiberglass Hereford bull perched atop a sixty-foot pedestal.

The Hereford in
Mulkey Square.
*Courtesy of the
author.*

The bull wears lightning rods and lights to ward off airplanes. Facing north, he gazes across a freeway toward a taller, bovine-free pedestal on a building at Eleventh and Jefferson Streets. Like all Herefords, he is brown and white. His eyes are red, as if tearfully remembering his old home and the day he came to town.

There had been bigger celebrations before. The city centennial comes to mind, along with the dedication of the Liberty Memorial and the end of World War II. Still, this was big.

"It reminded me of the time the armistice was signed back in 1918, the way everyone acted," a city councilman said at the time.

"This is a fitting climax to the growth of the city the last five or six years," said the chamber of commerce president.

"It's a great thing," said a barber in a shop on Eleventh Street. "All my customers are really happy today."

"This is grand for the town and the area," said the mayor. "It should bring more business, more money, more enthusiasm, more visitors and more friends to Kansas City."

"It is destined to be one of the most talked-about cities in the United States," said a local sales manager.

It was October 13, 1954, the day after the bull arrived. But they weren't talking about the bull.

"Everyone is tickled pink," said the owner of a beauty shop on Troost. "All of the girls are talking baseball today."

"I will call them the Kansas City A's," said the man who was moving the Philadelphia A's to town. "I've always liked that name."

The owners of American League teams had gathered the previous morning at the Blackstone Hotel in Chicago to decide the fate of the Philadelphia franchise.

It was a team with a history of success (Eddie Collins, Jimmie Foxx and Lefty Grove and five World Series championships) that had fallen on hard times. Twenty-three years had passed since the last pennant. No more than 150,000 paying fans were expected to watch them play a 1955 season in Philadelphia. The longtime owner, Connie Mack, was ninety-two and out of money. He and his sons needed to sell.

Chicago businessman Arnold Johnson, who planned to move the team into an expanded Blues Stadium here, was thought to have the best offer. But rumors suggested a possible sale to interests in Los Angeles or Washington, D.C., or even Philadelphia.

The meeting was scheduled for 11:00 a.m., but heavy rains and flooding in Indiana delayed the train bringing one of the Macks to Chicago. It finally convened at 1:00 p.m. Ten hours later, a league official announced unanimous approval for Johnson's bid.

The next day's front-page, banner headline declared: "KANSAS CITY GOES BIG LEAGUE."

As the baseball meeting was getting started in Chicago, another move was underway at the same hour in Kansas City. As with the meeting, weather played a role. Heavy rains and wind the previous day had delayed delivery of the plastic-and-steel bull—twelve feet by twenty feet and almost three tons—through downtown streets on a flatbed trailer to the top of a ninety-foot pylon on the American Hereford Association headquarters at Eleventh and Jefferson.

"We hauled it all the way from New Jersey," said the mover. "And we're sure not going to bust him up now."

The bull made his way from storage at Nineteenth and Forest. He headed north on Oak to Eleventh and then west. He passed the barber shop near Grand, its chairs full of hopeful baseball fans, and then a jewelry store in Petticoat Lane, the one whose recent newspaper ad pictured a boy kneeling at his bed, asking God to "please bring the A's to Kansas City."

At Jefferson, a man climbed aboard the bull's back and a crane lifted them skyward. Someone had flipped a coin and determined which direction the bull should face, and so the man helped point him north and bolted him onto the downtown skyline.

It's not known if the bull then inspired anyone to say anything about more business, more money, enthusiasm, visitors or friends for Kansas City.

The American Hereford Association would abandon the bull many years later, and he would be moved south just a few blocks to a new dedicated pylon in Mulkey Square, high above the west-bottoms site of the old stockyards.

As the *New Yorker*'s Calvin Trillin would write of the relocation, "It may be that my home town is more willing to be known as a cowtown now that it isn't one."

It should be noted that the Kansas City A's mascot, inherited from Philadelphia, was a white elephant. A white elephant, says Webster's, is "a property requiring much care and expense and yielding little profit." The elephant would stay in town for thirteen losing seasons and then move on, leaving the bull as the only oversized, four-legged reminder of the day Kansas City went big league.

Waiting Near the Robert E. Lee

A concrete staircase rises from the northwest corner of Thirteenth and Wyandotte to the Barney Allis Plaza, which is an elevated urban oasis—trees, grass, pergola, fountain and café tables—that fills an entire block of the downtown convention district. Besides providing a green roof for an underground parking garage, it's the site of festivals and professional tennis matches.

It's hard to dispute its value in an urban setting, unless you consider what was lost.

It was early spring but a nice night for a drive with the windows down. By 8 o'clock on that second Friday in April 1954, the afternoon's strong breezes had died. The air, still warm, carried threads of music. The recorded Eddie Fisher, Doris Day or Perry Como wafted from lighted apartments. Perhaps a shaky accordion riff was traceable to the rent-to-own promotion at Jenkins Music Company.

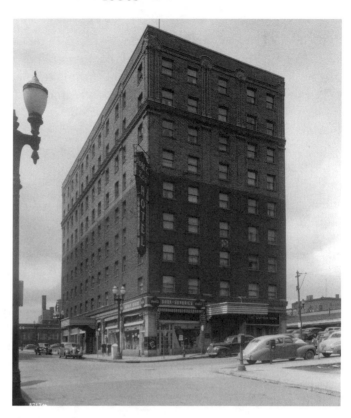

It was just twenty-eight years old, same age as the Hotel President. *Courtesy of Missouri Valley Special Collections, Kansas City Public Library, Kansas City, Missouri.*

People leaving the Home Show at Municipal Auditorium were talking about portable televisions, Orlon drapes or asbestos floor tiles. Or perhaps they talked about the news that Negroes would be admitted to the Swope Park pool that summer.

Across the street, two crane operators were working late, swinging wrecking balls against the carcass of a nine-story building, the Robert E. Lee Hotel at northwest corner of Thirteenth and Wyandotte. There was a low drone of cars out for a night on the town.

One sedan idled at a red light alongside the Robert E. Lee. Inside, a middle-age husband and wife from Leavenworth were perhaps wishing for a convertible instead of a hardtop. Then the light was green, and the husband, wearing a jacket and bowtie and waiting for pedestrians to clear, heard a sound overhead—like something falling. He hit the gas.

The city had decided the Robert E. Lee was expendable. Others wondered why the hotel couldn't be saved. It was just twenty-eight years old, same age

as the Hotel President around the block. Its condition was good. Its location, steps from the auditorium, was ideal. And two-hundred-room hotels don't grow on trees in towns hoping to attract convention business.

A move was seriously considered. Contractors said the nine-story, six-thousand-ton, concrete-and-steel-framed Robert E. Lee could be cut off its foundation, jacked three inches off the ground, put on rollers and coaxed across the intersection on railroad tracks to a site at the southeast corner of Thirteenth and Wyandotte.

Estimates for the move came in at $500,000. The city said that was too much, even if the cost for a new hotel to replace the Lee would be more than $2 million.

Bowtie was peeling through a left turn when something hit the roof of the car, sounding like an explosion. Shaken, he pulled to a curb down the street. His wife was pale, speechless. He got out and looked back at pedestrians scattering, with white dust billowing off the pavement. There was a crater in the car's roof; chunks of Robert E. Lee concrete lay about, five hundred tons of it. No one was hurt.

So they moved on, out-of-towners headed to the Hotel Muehlebach for the night, possibly unaware of the back-story in their near-death experience—that Kansas City was trashing a perfectly good hotel in order to build a municipal parking lot of twelve hundred spaces underground.

Neither, perhaps, did they know it was not the only demolition project underway downtown. Several solid, ornate nineteenth-century buildings near Sixth and Delaware were coming down to make way for the future Intercity Freeway.

Probably they knew of the expanding culture of cars and the progress it promised. But I wonder whether they were ever able to appreciate the Robert E. Lee's act of deathbed defiance, striking a small blow for proud, useful and unwanted buildings.

Poised Between Seasons

I'm standing just beyond center field on Brooklyn Avenue near Twenty-first Street, looking west toward home. A major-league home that's under construction. It's a bright, late-winter Wednesday afternoon with mild temperatures foretelling spring.

Municipal Stadium under construction, March 2, 1955. *Courtesy of Missouri Valley Special Collections, Kansas City Public Library, Kansas City, Missouri.*

Winter's makeover has transformed Blues Stadium into Municipal Stadium, adding an upper deck, new plumbing, wiring, lights, seats, locker rooms, concession stands and parking. Spring will bring new tenants: the Athletics, formerly of Philadelphia.

You can see Lincoln High School just to the right of the upper deck. If you panned right, you would see the sun-washed city skyline a couple of miles distant, where the Parade of Cars is underway, bearing the Queen of the Motor Show and her seventeen princesses through the streets of downtown. The cars are stylish like the Dodge La Femme or futuristic like the Buick Wildcat II. The queen and princesses are comely young women in tiaras and strapless gowns.

People downtown are talking about the cars; the warm weather; the opening of Missouri's trout season; the city election, with H. Roe Bartle winning the mayoral primary; KU's defeat of K-State last night in Lawrence, the first game in the new Allen Fieldhouse; or yesterday's atomic-bomb test in Nevada, which had no more radiation than a chest X-ray, so they say.

Downtown clothiers are having sales on wool overcoats as they bring out the new straw hats. A few department stores are advertising air conditioners and lawn mowers. You could buy a pair of shoes at Millman's on Walnut and get a pair of tickets to an A's game.

Soon it will be Opening Day. Today, here on Brooklyn Avenue, the ballpark is about two-thirds finished. Fourteen hundred miles away in Florida, the Kansas City Athletics have just begun spring training. In six weeks, they'll be right here, winning their first game.

Tonight, the star Regulus and the springtime constellations will be seen in the eastern skies. But the brightest lights in the heavens still will be Jupiter and the constellations of winter. Tomorrow will be warm, but Canadian air is on the way.

It's a town in transition, poised between winter coats and spring hats, basketball and baseball, minor league and major league. Between yesterday's news and whatever's ahead.

GRITTY ELEGANCE

I visited the old streetcar recently, with it being the same week Kansas City's streetcars made their final runs in the summer of 1957.

It's possible to look at the cream-and-black streetcar—partially restored, destination sign reset to "Country Club" and lying in state on a segment of track in a little green shelter in the parking lot west of Union Station—and think of, say, Lenin's Tomb.

I wasn't thinking of a tomb. Neither was I thinking much about that rainy June weekend in 1957: Jewell Ball debutantes at the Nelson; Liberace playing to huge crowds at Starlight; a three-paragraph newspaper article headlined "STREET CARS QUIETLY FADE FROM SCENE," a streetcar operator on his last run saying, "You'll never have better service than from a streetcar. Any kind of weather, twelve months of the year, 365 days a year, you'll never get better service."

I wasn't thinking about the traffic engineers of the 1950s who proposed "a metropolitan expressway system," which would "allow traffic to reach the central business district at high speeds from remote points." Nor was I thinking that the engineers aimed "both to indicate the need to the people of Greater Kansas City and to convince them of the need for such a system."

I wasn't thinking the planners really were enablers for a growing public addiction to automobiles and far-flung suburbs; that they'd made it an either/

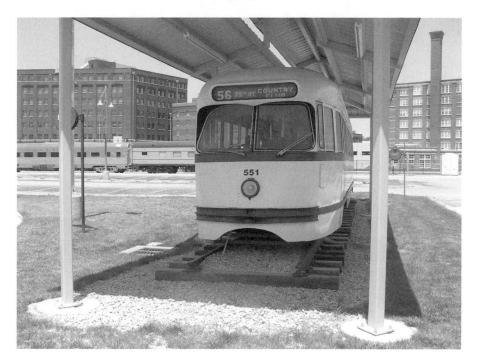

The streetcar under its shelter. *Courtesy of the author.*

or question: either autos or streetcars; or that they might have imagined instead a peaceful co-existence.

I was thinking, what a beautiful object is this streetcar.

Streamlined—that's a 1930s term for all things sleek. It's a design featuring flowing lines, described by copywriters of the time as "symbolic of contemporary life."

"Like a falling drop of water. The smooth gliding of the fish."

There were streamlined pianos and streamlined passenger trains and streamlined teakettles, vacuum cleaners, autos, flashlights, bicycles, refrigerators, golf clubs, beds, milk bottles—and streetcars.

The streamlined streetcars of the late 1930s improved on their boxy, rigid predecessors: lighter, faster, smoother, quieter and more comfortable. In 1941, Kansas City got 24 of them. Five years later, 160 more.

Today, out in California, the diverse mass-transit options in the city of San Francisco include restored vintage streetcars painted in the colors of other cities' fallen fleets. My favorite is car 1056, a streamliner wearing the cream-and-black of the Kansas City Public Service Company.

To ride on 1056 is to feel the electric whir of the motor, the metallic grind of the wheels, the brassy ring of the bell and that je ne sais quoi that is Paris of the Plains. It is public transit with a sort of gritty elegance and a timeless blend of beauty and function, plus something essential that puts a smile on faces.

Down at Union Station, I was thinking this streetcar in its little shelter looked more like a gift in a box. I imagined it as a full-scale model, part of a life-size layout, with a few miles of track and a no-frills set of streetcars gliding like fish between the City Market and the Plaza. Restored streamliners, restoring the Main to Main Street, some Grand on Grand Boulevard and a few more lights along Broadway.

And something essential, long ago lost.

EPILOGUE

It is terribly important that the "small things forgotten" be remembered. For in the seemingly little and insignificant things that accumulate to create a lifetime, the essence of our existence is captured.
—*James Deetz,* In Small Things Forgotten: The Archaeology of Early American Life

A few years ago, I gutted a run-down 1924 bungalow on Wyoming Street, preparing it for renovation. As its old walls and ceilings came down, they surrendered small secrets: fragments of handwritten letters in the attic, coins under baseboards, tarnished rhinestone hatpins, yellowed newspaper, rusted tools, broken toys, shoes, a wooden clothes hanger and other things. Carefully lifting each item from the debris, I laid it in a cardboard box.

At night I studied the artifacts, trying to determine their ages and imagining their owners. The house had not seen significant redecorating or renovation since 1958, and it was clear most of the things dated from its first thirty-odd years.

The artifacts told stories. For example, a dog-eared booklet that once held twelve two-cent stamps brought up the possible journey of a letter mailed in 1924: coast to coast in four days by automobile, bicycle, motorcycle, motorboat, steamboat, conveyor belt, pneumatic tube, horse, wagon or sled but primarily by train, in post office cars piled high with mail and sorted en route by railway clerks. An empty package of Chesterfields with a 1943 tax stamp suggested parachutes blooming like moonlit flowers and American GIs falling slowly toward the stony surface

of Sicily with one hundred pounds of gear: tommy gun, pistol, bayonet, grenades, medical equipment, rations and cigarettes. The wooden hanger, imprinted with advertising from a 1920s cleaning shop almost six miles away, disclosed the nearby previous home of the Todd family, the first residents of my bungalow.

For some reason, maybe because their times roughly corresponded to my mother's first thirty-odd years, the artifacts made me think of her family.

In the early 1920s, her mother's parents moved into a new home on Sixty-second Street, a couple miles south of the Wyoming Street house. A snapshot has my great-granddad, who was born the year before Custer's Last Stand, standing on the front porch in a striped shirt, tie, light-colored trousers and white shoes. In another, my great-grandmother, two years his junior, poses there in a springtime frock and straw hat. Inside their house, I reasoned, were things like those I had found: wooden hangers in the closets and rhinestone hatpins on the dressing table.

A few artifacts were linked to specific Kansas City places, and I went looking for those theaters, shops or churches. Some no longer existed, but even a vacant lot got me wondering. If broken toys told little stories, what seemingly insignificant things would a vacant lot talk about?

Eventually, I realized: looking for Paris of the Plains was a way of excavating the world of my ancestors. So the idea for a Great War memorial just south of Union Station arrives about the same time my great-granddad's new employer, having bought out his family's business, is settling into new headquarters just north of the station.

The year Fritz Peterson comes home from that war, thinking he may go west, is the year my grandfather does come west, from Sedalia, Missouri, to Kansas City after his army discharge. And a sleepwalking Chicago lawyer wakes up near Tenth and Grand the same year my grandparents marry.

Frightened Hereford steers roam the streets a month before my mother's birth, and early one morning before her fifth birthday, her mother watches the nefarious neighbors leave for their fateful workday. A doctor is getting his receipt at Woolf Brothers as my great-grandmother is planning a summer vacation trip with her daughter and granddaughters, and a Filipino boy driving them in a new Ford through the Dust Bowl to California. Men in overalls raze the Hotel Baltimore as my mother and aunt take lessons in cigarette smoking from the Negro maid.

Tom Pendergast's funeral Mass is held a few blocks from my grandparents' house, where ten weeks later my grandfather sits down to dinner after hearing of President Roosevelt's death and says, "The country's been saved."

As the elevator is falling at Harzfeld's, Mom is preparing to marry a Kansas boy and move to a windy town on the Great Plains. While the undefeated Knights of Southeast practice for the big game against Rockhurst, her parents await the arrival of their first grandchild. And the year the city loses its eighty-seven-year-old streetcar system is the year my family loses its eighty-year-old matriarch, my Victorian great-grandmother.

They may have been teetotaling, church-going Republicans in Tom Pendergast's Democratic fiefdom (they always called him Mister Pendergast), but this was their town, too. And now I can place them in it.

Today the Kansas City skyline is taller, sleeker and more corporate than in 1950. Steel-and-glass office boxes have replaced chunky brick warehouses topped with beer signs and train billboards. Interstate highways loop a high-speed noose around what used to be called the central business district.

And yet, "PRESIDENT" beams from the roof of that renovated hotel. The nine-floor H.D. Lee building where my forebears worked has new life as loft apartments. The sleek, glass bowl of an arena has replaced vacant asphalt. A new performing arts center, suggesting a huge, graceful seashell, rises amid construction cranes on the hill behind a refurbished Union Station.

From the Liberty Memorial observation deck, I can see both the end and the beginning. Across the street under its little green canopy alongside Union Station, there's the dormant streetcar representing loss. And here beside me is the Memorial itself, conceived as a symbol of hope. They are like bookends for my state of mind, for this Paris of the Plains.

ABOUT THE AUTHOR

 John Simonson is an independent writer and editor. His work has appeared in local newspapers, magazines, websites, corporate publications, museum exhibits, jazz recordings and beyond. He lives in Kansas City, Missouri.

Visit us at
www.historypress.net